POSTCARD HISTORY SERIES

Amarillo

ON THE FRONT COVER: AMARILLO AND RULE BUILDINGS, POLK STREET. This is a view looking north on Polk Street. In the center of the card are the Amarillo and Rule Buildings. The Rule Building was constructed in 1927 on the northeast corner. On the right are the KC Waffle House and the Oklahoma Hotel. Farther down the street is the Mission Theater. At the far end of the street is the Amarillo Ice Company. On the left is the Famous For Food Restaurant, which was in the south end of the Amarillo Hotel. (City Drug Store, *c.* 1930.)

ON THE BACK COVER: AUTO SHOW, JULY 27, 1909. Decorated with flowers and telephones, this car was sponsored by Pan Tel and Telephone Company. The driver has his dog in his lap, and the dog has a hat on that states, "PT&T Co." This is a 1909 real photo postcard.

POSTCARD HISTORY SERIES

Amarillo

Ron Smith

ARCADIA
PUBLISHING

Published by Arcadia Publishing
Charleston SC, Chicago IL, Portsmouth NH, San Francisco CA

Printed in the United States of America

Library of Congress Control Number: 2009922902

For all general information contact Arcadia Publishing at:
Telephone 843-853-2070
Fax 843-853-0044
E-mail sales@arcadiapublishing.com
For customer service and orders:
Toll-Free 1-888-313-2665

Visit us on the Internet at www.arcadiapublishing.com

*In loving memory of my parents, Chet and Helen Smith, and for all the rest
of my family, especially for my wife, Esther Smith*

CONTENTS

INTRODUCTION

The largest city in the Texas Panhandle, Amarillo was actually founded twice. It was originally founded by J. T. Berry in April 1887 and named Oneida. Then on June 19, 1888, Henry B. Sanborn began buying land a mile east as a new town location. Sanborn is known as the father of Amarillo. He claimed that the original town site was on low ground and would be susceptible to flooding during rainstorms. In 1889, heavy rains almost flooded the original town site and prompted more residents to move to Sanborn's new location. Around the late 1890s, the railroads made their way into town, helping Amarillo become one of the world's busiest cattle-shipping points and causing the population to grow significantly—in people as well as cattle.

Gas was discovered in 1918, and oil was discovered three years later. Oil and gas companies set up shop in the area. In 1927, the U.S. government bought the Cliffside gas field, which had high helium content. Two years later, the Federal Bureau of Mines began operating the Amarillo Helium plant from this gas field. Amarillo was once the self-proclaimed helium capital of the world—as if one nickname is not enough—for having one of the country's most productive helium fields. The city is also known as the "Yellow Rose of Texas," as the city takes its name from the Spanish word for yellow. The city was also crowned "Beef City" because of its growth as a cattle-marketing center in the late 19th century.

When Amarillo was hit by the dust bowls in the 1930s, it entered an economic depression. As in many other parts of the country, it was World War II that spurred the local economy. Amarillo's economy continues to thrive on cattle, along with agriculture, oil, and natural gas. Amarillo Army Air Field, which was located in east Amarillo, and the nearby Pantex Army Ordinance Plant, producing bombs and ammunition, were both established in 1942 during World War II. The city's depression ended with the arrival of servicemen and their families to the area. The Pantex Army Ordinance Plant closed in 1945 and then reopened in 1950. The Army Air Field closed at the end of World War II in 1946 and then was reopened in 1951 as the Amarillo Air Force Base. In 1968, the air base closed for good.

U.S. Highways (Routes) 60, 66, 87, and 287 merged at Amarillo, making it a major tourist stop with numerous hotels, tourist camps, motels, restaurants, and curio shops. Places of special interest include the Cadillac Ranch and the Big Texan Steak Ranch, both of which are on the former Route 66. Amarillo is the only area on Route 66 where one cannot follow and drive on the original Route 66. Most of the original highway is still in existence across the country, and one can actually drive on it. The Amarillo airport has taken over parts of the original Route 66, thus making it impossible to follow the original road. Also found here are the Texas Panhandle War Memorial; American Quarter Horse Association and Museum; and Panhandle Plains Historical Museum, the largest history museum in Texas. South of Amarillo

is the Palo Duro Canyon State Park—Texas's grand canyon. In the Palo Duro Canyon, the Pioneer Amphitheater presents the outdoor musical drama *Texas*.

Amarillo's Rick Husband International Airport has the third-largest runway in the world and is designated as an alternate landing site for the space shuttle. This large runway was built in the 1950s when the Amarillo Air Force Strategic Air Command (SAC) base was here.

I have been an avid postcard collector for over 20 years, collecting mostly postcards of Amarillo, Texas, and the surrounding towns. I only collect postcards that are of the standard size and not the newer, larger continental postcards. The town name of Amarillo was spelled, and misspelled, several different ways through the years. It has been spelled as Amarillo, Amarilla, Amorillo, and even Amarylla.

The history of Amarillo has always intrigued me, and the postcard collection created an unintentional history of the place—so I decided to create a book. I have always enjoyed the challenge of getting a postcard I didn't have before. When I first started collecting, the Internet did not exist, so finding postcards required trips to antique stores, antique shows, flea markets, auctions, and postcard shows.

My postcards feature all kinds of popular places, such as churches, banks, hotels, motels, restaurants, and important buildings. Some of the older cards are the real photo postcards for which the card company basically took a photograph and made that a postcard. For some of these, only one or two cards were produced. Other times, a hundred or so were made. The challenge was in finding the cards that were still around. So often, people just trash their old postcards. It is always interesting to see cards that show how they have changed over the years. Disasters were always a very popular subject. When there were fires, tornados, and other disasters, the postcard people were out taking pictures. A lot of different stores would carry postcards for people to buy.

When I first started trying to put this book together, my major challenge was to figure out which postcards would work best for this volume. I had about 1,000 cards to choose from. I decided to use the oldest postcards that I had and build from there. I also decided to end the book in the late 1950s. This decision allowed me to narrow my search down to about 350 selections. After choosing the best of the lot, I finally settled on about 200 postcards for this book.

One

VARIOUS VIEWS
AND RESIDENCES

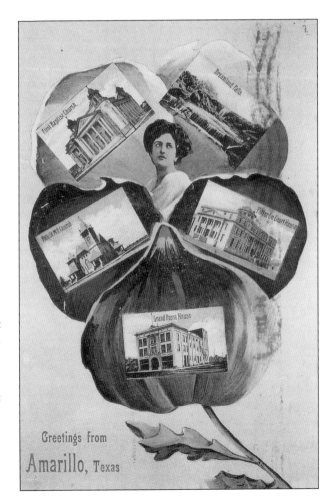

GREETINGS FROM AMARILLO, TEXAS. This is a fancy and colorful multi-view postcard that reads, "Greetings from Amarillo, Texas." The five views featured here are First Baptist Church, Dreamland Falls, Polk Street M. E. Church, Potter County Court House, and the Grand Opera House. The buildings are in Amarillo, and Dreamland Falls is in Palo Duro Canyon, which is south of Amarillo. (The PCK Series, 1909.)

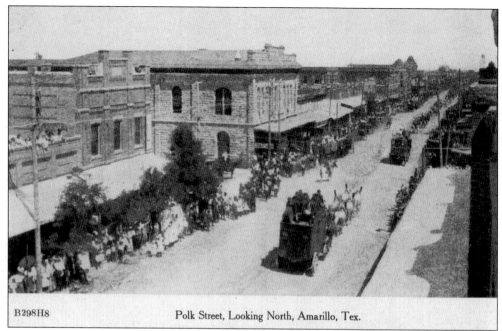

B298H8 Polk Street, Looking North, Amarillo, Tex.

POLK STREET, LOOKING NORTH. This street scene shows the circus coming to town. It looks like almost everyone in town has lined the street to welcome it. The building in about the center of the card is of the old opera house at Fifth Avenue and Polk Street. Note the trees in front of the buildings that are no longer there. (H. G. Zimmerman and Company, *c.* 1907.)

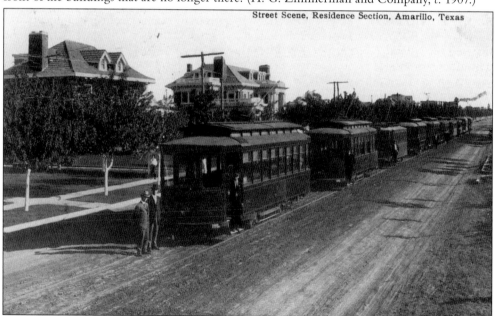

Street Scene, Residence Section, Amarillo, Texas

STREET SCENE, RESIDENCE SECTION. This 1921 postcard shows a view, looking north, of about 10 streetcars with their operators. This was the main streetcar line in town, operated from around 1908 to about 1923. Polk Street was the main street and as such was the primary road that the streetcars traveled. The house on the left is the residence of J. D. Shuford at 1608 Polk Street. The next house down is the residence of P. H. Landergin at 1600 Polk Street.

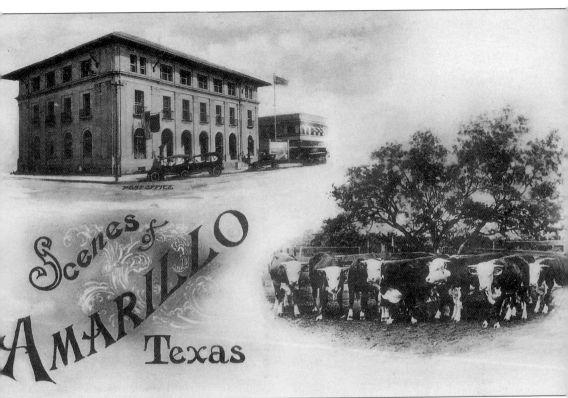

SCENES OF AMARILLO. This postcard is titled "Scenes of Amarillo, Texas." Multi-view cards were very popular. This scene shows the old post office at 620 South Taylor Street. It was the first post office building in Amarillo and was constructed in 1914. Prior to this building, the post office was located at different businesses in town, such as banks, real estate offices, and grocery stores. It also shows a herd of cattle on a ranch. Cattle and ranching became a main commodity of Amarillo shortly after it was founded and continues to be so today. Amarillo has a major livestock auction that sells around 300,000 cattle a year. Located in the old stockyards area along East Third Avenue, it is one of the largest independent auction houses in Texas. (The Albertype Company, *c.* 1920.)

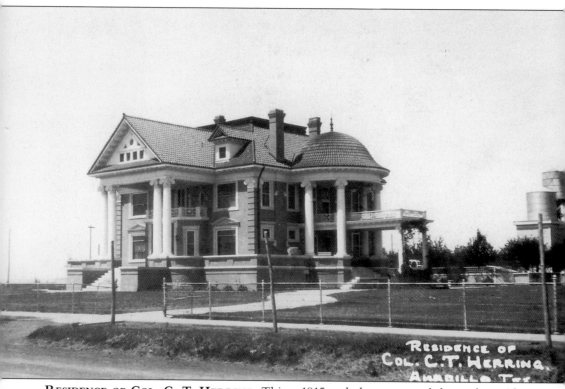

RESIDENCE OF COL. C. T. HERRING. This *c.* 1915 real photo postcard shows the residence at 2304 Van Buren Street that was built in 1907. Col. Cornelius Taylor Herring built the Palo Duro Hotel and the Herring Hotel. The two-and-a-half-story mansion was way out in the country when it was built. The house was eventually demolished, and Amarillo College now owns the land.

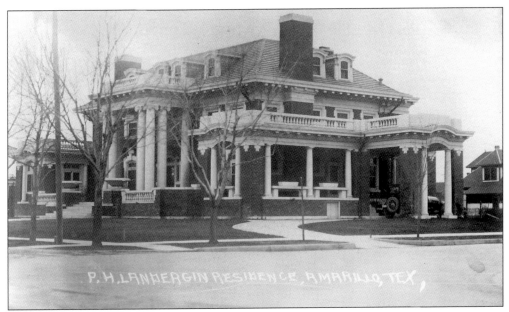

P. H. LANDERGIN RESIDENCE. This *c.* 1916 real photo postcard shows the residence at 1600 Polk Street. Pat and John Landergin were cattle barons. Built in 1913, the two-and-a-half-story-tall, 15,000-square-foot mansion has a working elevator. The streetcars ran in front of the house. Don and Sybil Harrington purchased the home in 1940 and lived there until 1983. Sybil then donated the house to the Panhandle Plains Historical Society. It still stands today.

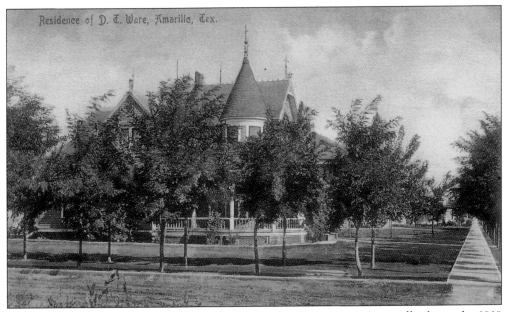

RESIDENCE OF D. T. WARE. This card contains a typing error, as it actually shows the 1010 Polk Street residence of B. T. Ware, not D. T. Ware. Built in 1902, the structure was demolished in the 1970s. Benjamin Ware started Amarillo National Bank, which remains in business today. (L. O. Thompson and Company, 1910.)

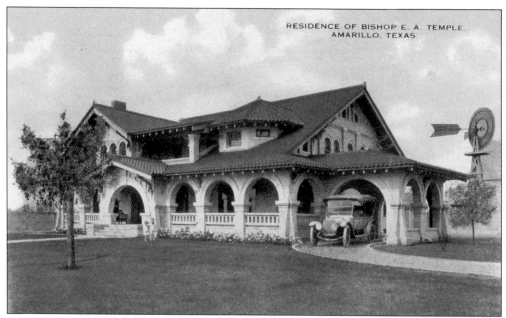

RESIDENCE OF BISHOP E. A. TEMPLE.
AMARILLO, TEXAS

RESIDENCE OF BISHOP E. A. TEMPLE. This residence was at 2200 South Harrison Street, which was out in the country. It was originally built around 1915 for Bishop Temple, a retired reverend of the Episcopal Church of North Texas, but it was home for several years to banker Charles A. Fisk. The house was demolished around 1980, and the land is now owned by Amarillo College. (Commercialchrome, *c.* 1920.)

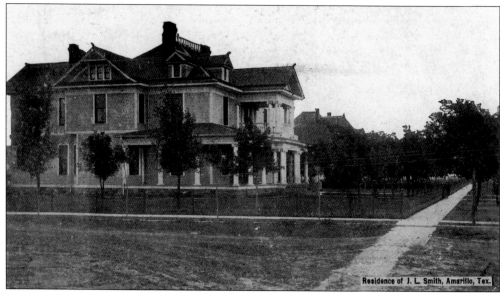

Residence of J. L. Smith, Amarillo, Tex.

RESIDENCE OF J. L. AND MARIE SMITH. This postcard shows the residence of businessman and banker James L. Smith at 1101 Taylor Street. Mr. and Mrs. Smith were both civic and church leaders. Mrs. J. L. Smith headed the Ladies Aid Society to help raise seed money for the First Baptist Church building. The house was moved to Ninth Avenue and Avondale Street so Plains Chevrolet could be built on the Taylor Street land. (Joiner Printing Company, *c.* 1920.)

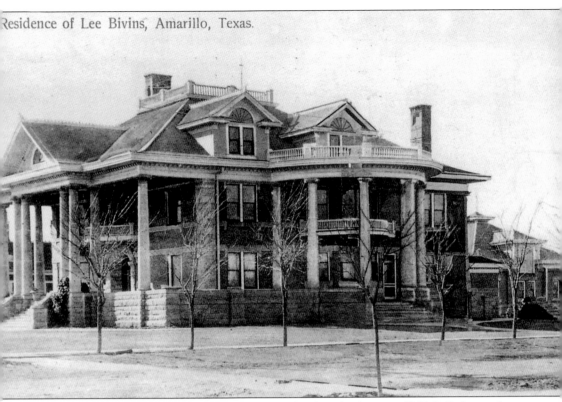

RESIDENCE OF LEE BIVINS. Lee and Mary Bivins lived in this home at 1000 Polk Street. Lee was a cattleman, major landowner, and was also once mayor of Amarillo. Constructed in 1905, the building served as the public library from 1955 to 1976 and is now the Amarillo Chamber of Commerce. (The Nickel Store, *c.* 1920.)

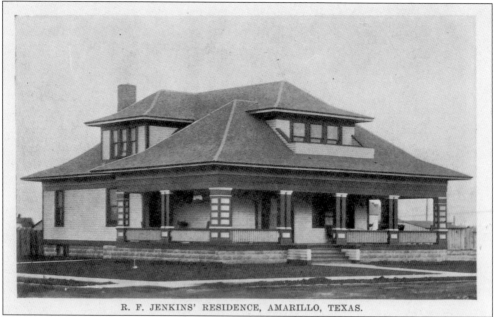

R. F. JENKINS' RESIDENCE, AMARILLO, TEXAS.

R. F. JENKINS RESIDENCE. This *c.* 1910 postcard shows the residence at 1501 South Taylor Street. Robert F. Jenkins was the pastor of the First Baptist Church for 15 years, starting in 1907. He was instrumental in getting a new church building constructed at Ninth Avenue and Polk Street in 1908. The house was built in 1910. This area later became zoned for business and was torn down.

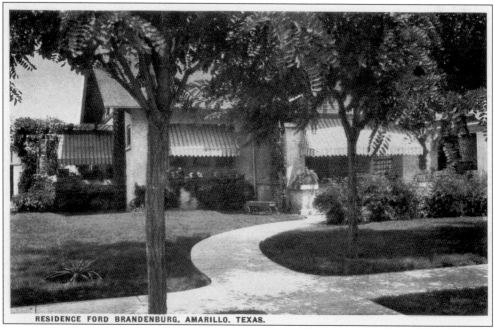

RESIDENCE FORD BRANDENBURG. AMARILLO. TEXAS.

RESIDENCE OF FORD BRANDENBURG. Ford Brandenburg was an executive at the First National Bank, the first bank in Amarillo. Built in 1912, this house was located at 1611 Van Buren Street. The house still stands today. (Commercialchrome, *c.* 1912.)

16

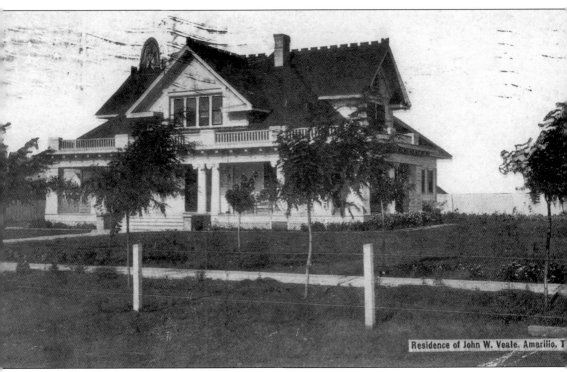

Residence of John W. Veale, Amarillo, T

RESIDENCE OF JOHN W. VEALE. Veale was instrumental in bringing the first streetcars to Amarillo in 1908. He was a lawyer and a district judge. This house was located at 1300 Madison Street and was built in 1907 and has since been demolished. (Joiner Printing Company, 1910.)

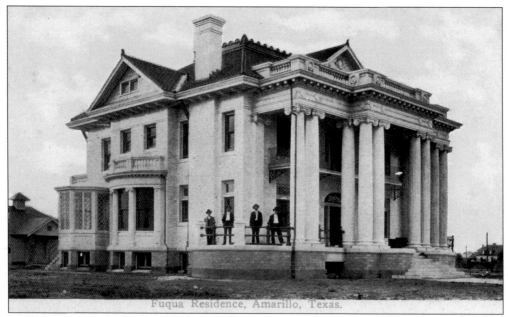

Fuqua Residence, Amarillo, Texas.

FUQUA RESIDENCE. Wiley Holder Fuqua was called the father of the First National Bank, and he served as its president for 40 years. This house was located in the 1400 block of Polk Street and was built just after the turn of the 20th century. It was later demolished to allow for the expansion of Amarillo High School. (ZIM, *c.* 1910.)

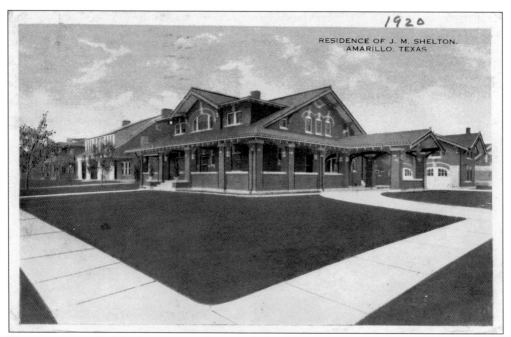

1920

RESIDENCE OF J. M. SHELTON.
AMARILLO, TEXAS.

RESIDENCE OF J. M. SHELTON. John M. Shelton was best known for owning the Bravo Ranch, which was originally part of the XIT Ranch. This house was located at 1700 Polk Street and was built in 1914. The house still stands today. (Commercialchrome, 1920.)

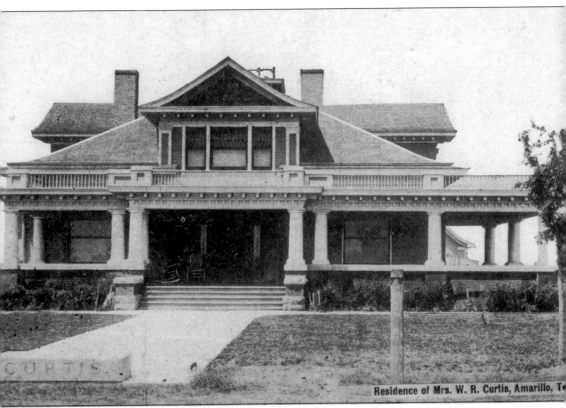

Residence of Mrs. W. R. Curtis, Amarillo, T•

RESIDENCE OF MRS. W. R. CURTIS. A Victoria G. Curtis was the mother of J. O. Curtis, who was a livestock agent for the Santa Fe Railroad. In front of the house one can see the Curtis name carved on a stone, and to the right of it is a hitching post. This house was located at 1626 Washington Street and was built in 1907. (Joiner Printing Company, 1908.)

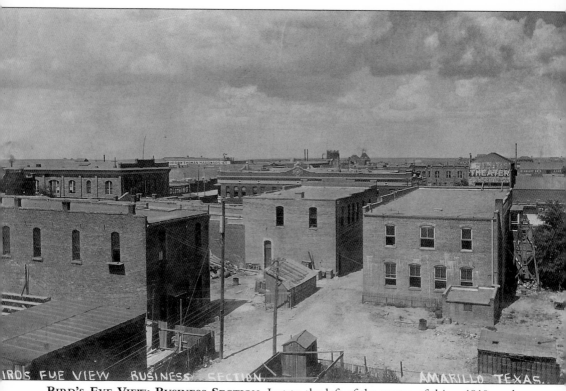

BIRD'S-EYE VIEW: BUSINESS SECTION. Just to the left of the center of this *c.* 1910 card, one can see the two-story building of Morrow Thomas Hardware Company at 316 Tyler Street. It was a major hardware company. To the left of that building is the old Opera House, which was located at Fifth Avenue and Polk Street. This picture was taken from around Sixth Avenue and Taylor Street looking northwest.

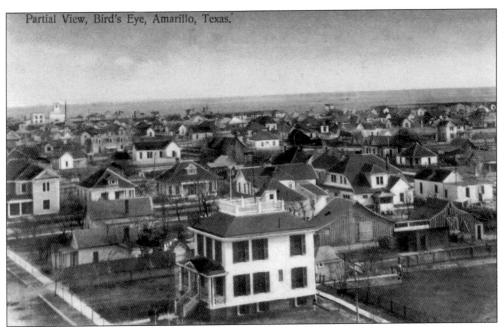

Partial View, Bird's Eye, Amarillo, Texas.

PARTIAL VIEW, BIRD'S EYE. The building in the front center is the Weather Bureau at 200 East Seventh Avenue on the corner of Taylor Street. On the left, just above center, is an old grain elevator, which is probably the Early Grain and Elevator Company that was built in 1909. This view looks southeast, mostly shows the residential area, and was probably taken from somewhere around the Potter County Court House area. (A. M. Simon, 1909.)

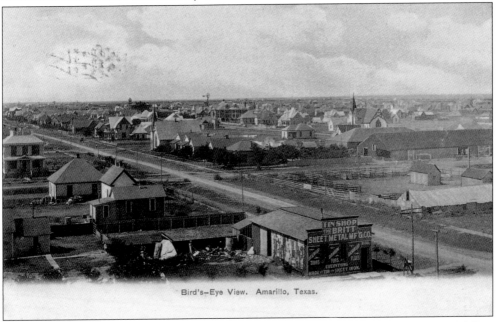

Bird's-Eye View. Amarillo, Texas.

BIRD'S-EYE VIEW. In the center of the card on the left edge is the Weather Bureau at 200 East Seventh Avenue on the corner of Taylor Street. Taylor is the street going from the bottom right of the card to the top left. In this southwest-facing view, one can see various livestock pens before they were not allowed inside the city limits. (Colorado News Company, 1907.)

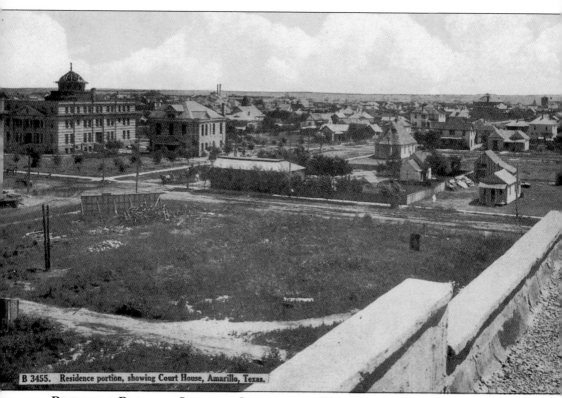

B 3455. Residence portion, showing Court House, Amarillo, Texas.

RESIDENCE PORTION, SHOWING COURTHOUSE. This picture was probably taken from the roof of the Grand Opera House, which was located at Seventh Avenue and Polk Street. On the far left, just above center, is the Potter County Court House and Jail. In this northeast-facing view, the courthouse still has the dome on top. (J. C. Leamon, 1909.)

Two

STREET VIEWS

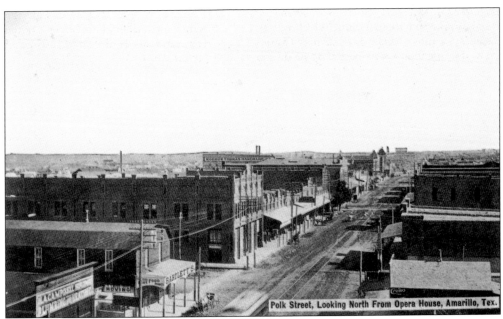

Polk Street, Looking North From Opera House, Amarillo, Tex.

POLK STREET, LOOKING NORTH FROM OPERA HOUSE. Polk Street is the main street in town. This view is from the Grand Opera House on the northeast corner of Seventh Avenue and Polk Street. In the front center foreground one can see a trolley, and in the bottom left corner is H. A. Campbell Plumbing and Heating. The next building north is Bartlett's Food Products on the southwest corner of Sixth Avenue and Polk Street. (Joiner Printing Company, 1909.)

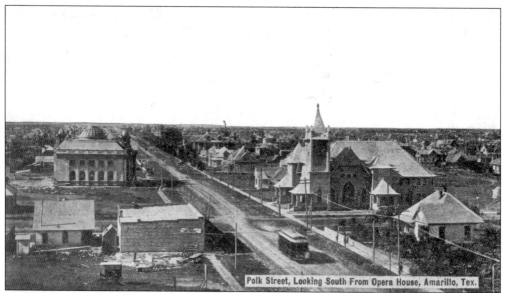

POLK STREET, LOOKING SOUTH FROM OPERA HOUSE. This view is from the Grand Opera House that was located on the northeast corner of Seventh Avenue and Polk Street. In the front center foreground one can see a trolley, which were around from about 1908 to about 1923. To the right side of the trolley one can see people walking on wooden sidewalks. The Polk Street Methodist Church is to the right of the center at Eighth Avenue and Polk Street. The building on the left, with the dome, is the First Baptist Church located at Ninth Avenue and Polk Street. (Joiner Printing Company, 1910.)

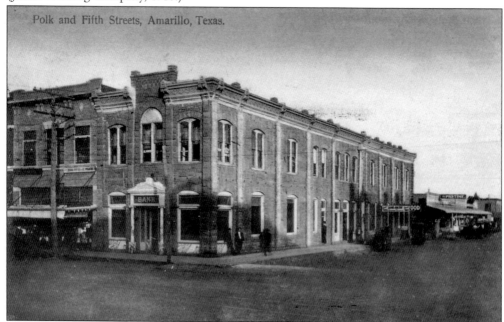

POLK STREET AND FIFTH STREET (AVENUE). This card was misprinted, and it should actually state, "Polk and Fourth Streets." This building is of the First National Bank, Amarillo's oldest (first) bank, on the northeast corner of Fourth Avenue and Polk Street. It was built in 1891. This card was published just after the turn of the 20th century. (A. M. Simon, 1909.)

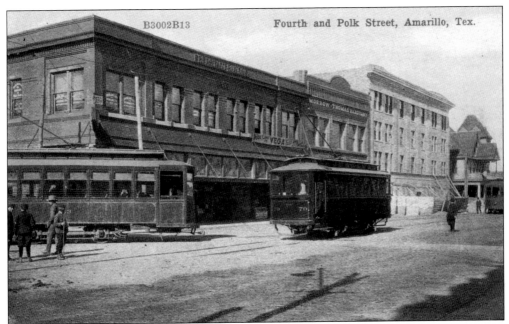

FOURTH (AVENUE) AND POLK STREET. The building on the far right is the original Hotel Amarillo, which was at the southwest corner of Third Avenue and Polk Street and was built in 1889. The building to the left of that is the hotel's new addition, which had an elevator. Next on the left is Morrow-Thomas Hardware. The Eberstadt Building is on the far left. (H. G. Zimmerman and Company, *c.* 1920.)

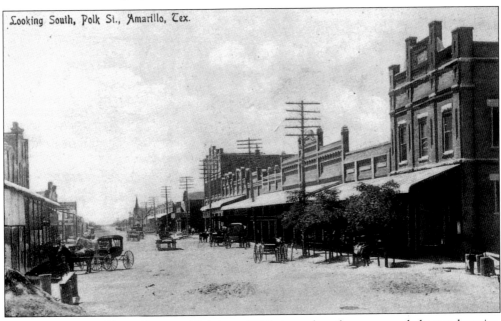

LOOKING SOUTH, POLK STREET. This is a *c.* 1900 view when there were only horses, buggies, and wagons and not any cars. This is the intersection of Fifth Avenue and Polk Street. The tall building located close to the center of the card is the old White and Kirk store that later became the home of Amarillo Hardware Company at Sixth Avenue and Polk Street.

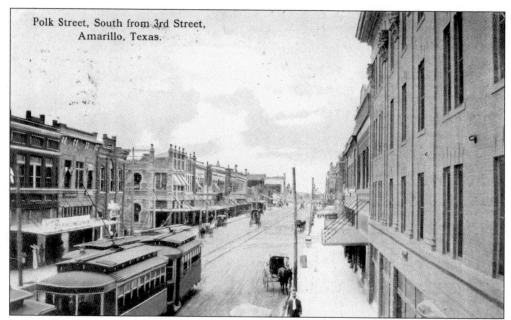

POLK STREET, SOUTH FROM THIRD STREET. This picture was taken in front of the old Hotel Amarillo on Polk Street and shows both electric streetcars and horses and buggies. The third building on the left is the First National Bank. The next building down is Amarillo National Bank. At this time frame, the streets are still dirt. (The Nickel Store, 1914.)

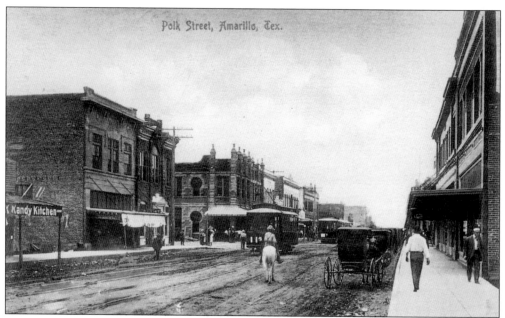

POLK STREET. This picture is looking south and was probably taken in front of the old original Hotel Amarillo at the intersection of Fourth Avenue and Polk Street. On the left is Dads Kandy Kitchen, and he peddled candy in a specially made wagon. He specialized in bags of taffy for a nickel. Two buildings down from Dad Boyles Kandy Kitchen is the First National Bank. The next building over is the Amarillo National Bank. (L. O. Thompson and Company, 1909.)

26

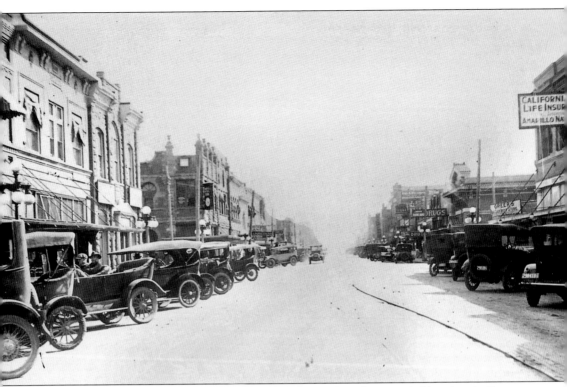

POLK STREET, SOUTH. This *c.* 1920 picture is looking south and was probably taken in front of the old original Hotel Amarillo at the south end. The intersection is Fourth Avenue. Two buildings down on the left is the First National Bank. The next building down is the Amarillo National Bank. The Amarillo National Bank building has the big clock on the corner of it. In the third car on the left, two people are looking at the cameraman.

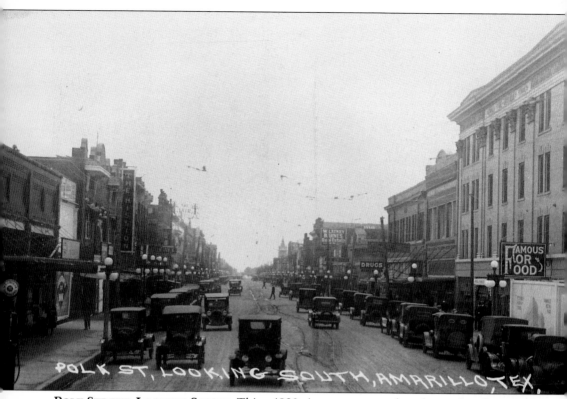

POLK STREET, LOOKING SOUTH. This *c.* 1920 picture appears to have been taken from right in the middle of Polk Street in front of the old original Hotel Amarillo. On the left is a Magnolia Gasoline pump, and down from there is the Mission Theater. On the right is the Famous for Food Restaurant in the south end of Hotel Amarillo.

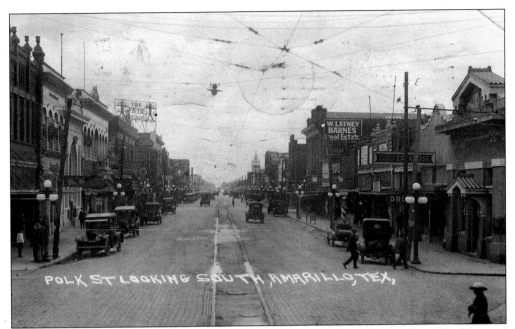

SOUTH SCENE ON POLK STREET. This 1922 picture was taken in the middle of Polk Street and Fourth Avenue. On the right is the Chanslor Building, home of Amarillo Bank and Trust, which later merged with the First National Bank. In the left center is the sign for the Fair Theater.

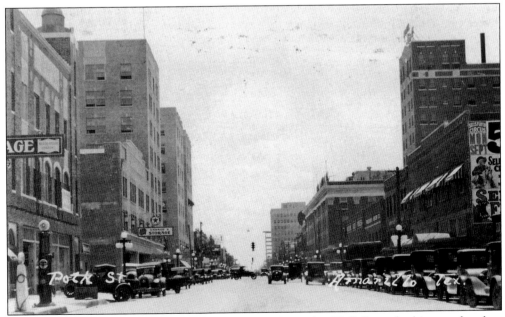

SECOND AVENUE AND POLK STREET. This 1928 picture is of Polk Street looking south, taken from the middle of Polk Street and about Second Avenue. The tall building on the right is the Hotel Amarillo at Third Avenue. On the left are gas pumps and garages. Across the street from the Hotel Amarillo are the Rule and Amarillo Buildings.

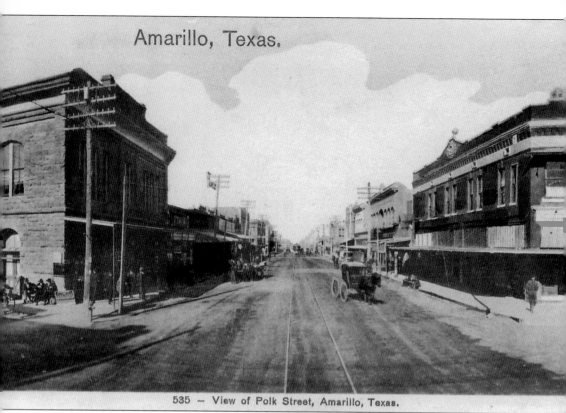

Amarillo, Texas,

535 — View of Polk Street, Amarillo, Texas.

VIEW OF POLK STREET. This card is of the intersection of Fifth Avenue and Polk Street, looking north. The building on the left is the original Opera House. This unique card contains 10 small views of Amarillo that one could slide out and look at. This view shows the area before the streets were paved with bricks. (W. G. Allen, *c.* 1909.)

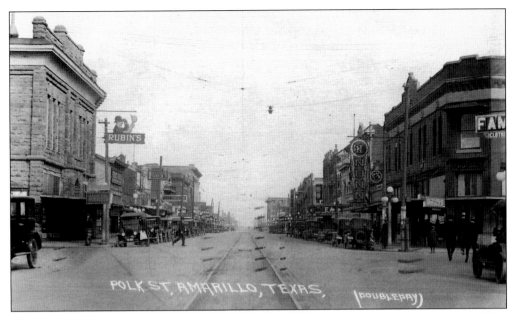

POLK STREET AND FIFTH AVENUE. This is a real photo postcard of the intersection of Fifth Avenue and Polk Street looking north. The building on the left is the original Opera House. On the right is the sign for the Nunn Electric Company, which carried the Victor talking machines. (Doubleday, 1921.)

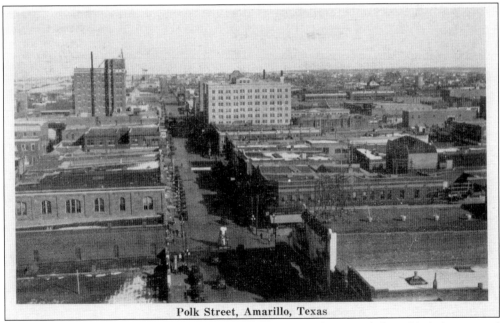

Polk Street, Amarillo, Texas

SIXTH AND POLK STREET. This is a view of Polk Street looking north from Sixth Avenue and Polk Street. The tall building on the left is the Hotel Amarillo. Across the street is the Amarillo Building. Just up from the bottom of the card in about the center one can see a traffic tower at the intersection of Fifth Avenue and Polk Street. (Bloom Brothers Company, *c.* 1940.)

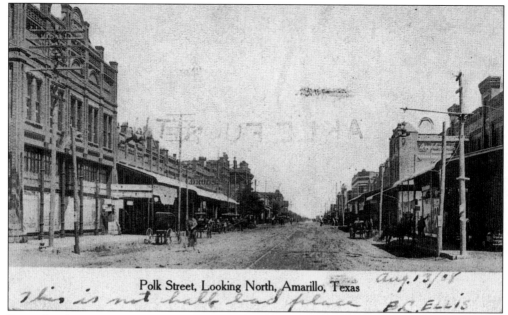

Polk Street, Looking North, Amarillo, Texas *Aug. 13/98*
This is not half bad place. *B. C. ELLIS*

POLK STREET, LOOKING NORTH. This 1908 card is of the intersection of Sixth Avenue and Polk Street looking north. In the center of the card there is a banner hanging that reads, "Eakle Furniture." At this time, there were horses and buggies but no automobiles. The building on the left is labeled "1903 Oliver Eakle Block," known as the Eakle Building, and it is where Amarillo Hardware was located in its second location. Before then, it was the home of White and Kirk. On the front of the card a person wrote, "This is not half bad place."

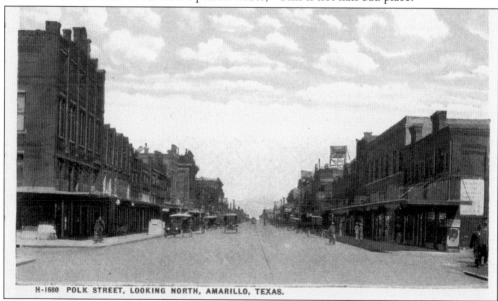

H-1680 POLK STREET, LOOKING NORTH, AMARILLO, TEXAS.

SIXTH AVENUE AND POLK STREET, LOOKING NORTH. This card is of the intersection of Sixth Avenue and Polk Street, looking north. In the center of the card one can see the trolley tracks, and in the far distance is a trolley. Automobiles were beginning to appear in town and are becoming more and more popular. The streets have also been paved with bricks. (Fred Harvey, *c.* 1915.)

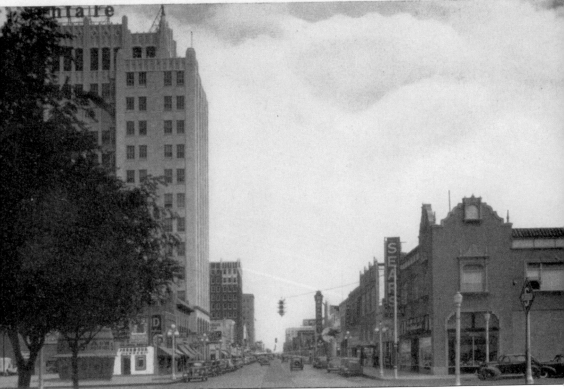

TENTH AVENUE AND POLK STREET. This is Polk Street looking north from Tenth Avenue. On the right is Sears Roebuck and Company. In 1957, Sears moved to Sunset Center. Farther down on the right is the Paramount Theater. On the left is the tall Santa Fe Building, the "king" of Polk Street, and then down from that is the Fisk Medical Arts Building. (Graycraft, c. 1950.)

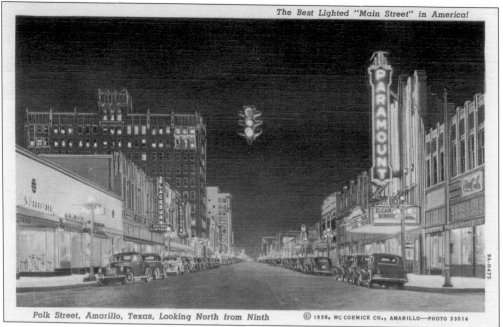

Polk Street, Amarillo, Texas, Looking North from Ninth © 1939, MC CORMICK CO., AMARILLO—PHOTO 33514

NINTH AVENUE AND POLK STREET, LOOKING NORTH FROM NINTH. "The Best Lighted 'Main Street' in America," is written on this postcard of Polk Street looking north from Ninth Avenue. On the right side is the Paramount Theater. The tall brown building on the left is the Fisk Medical Arts Building. (McCormick, 1939.)

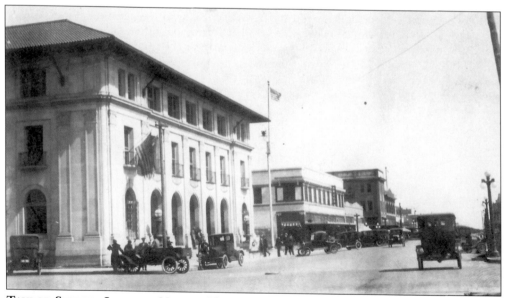

TAYLOR STREET, LOOKING NORTH. This *c.* 1920 card is a real photo postcard view of Seventh Avenue and Taylor Street. The building on the left is the post office at 620 Taylor Street, and it was built in 1914. This was used as a post office until 1939. The structure is still there today and is known as the Coble Building. The third building up, a three-story structure, is the Amarillo Telephone Building at Sixth Avenue and Taylor Street.

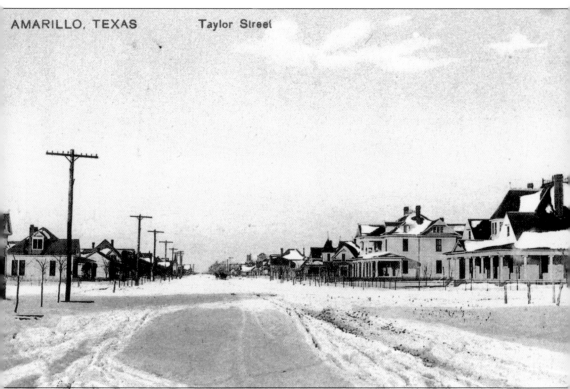

AMARILLO, TEXAS Taylor Street

TAYLOR STREET. This is a view of the residential section on Taylor Street in the snow, looking north. The second house down on the right side is the home of Mr. and Mrs. J. L. Smith at 1101 Taylor Street and was built around 1903. Mr. and Mrs. Smith were both civic and church leaders. Mrs. Marie Smith headed the Ladies Aid Society to help raise seed money for the First Baptist Church building. (L. O. Thompson and Company, *c.* 1910.)

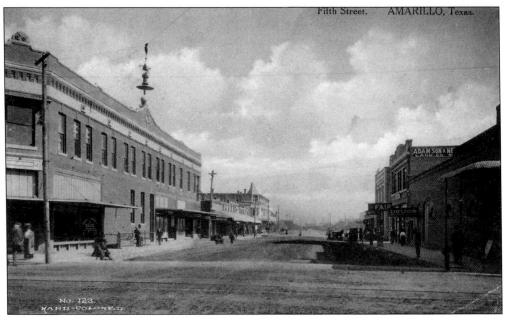

FIFTH STREET (AVENUE). This card is a view of Fifth Avenue and Polk Street looking east on Fifth. The Elmhirst Hotel can be seen on the far left end towards the middle of the card. The site of the Elmhirst is where the Federal Building was built on Taylor Street. On the right side is the Fair Department Store. (Fred Harvey, 1910.)

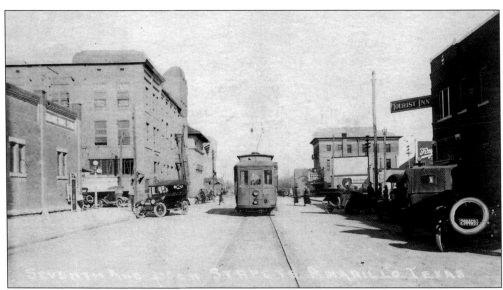

SEVENTH AVENUE AND POLK STREET. This c. 1920 real photo postcard looks east on Seventh Avenue. The building on the right is the Tourist Inn. The big building up on the left is the Grand Opera House at the Polk Street intersection. The next building down is the post office at the corner of Taylor Street that was built in 1914.

Three

BUSINESSES
AND BUILDINGS

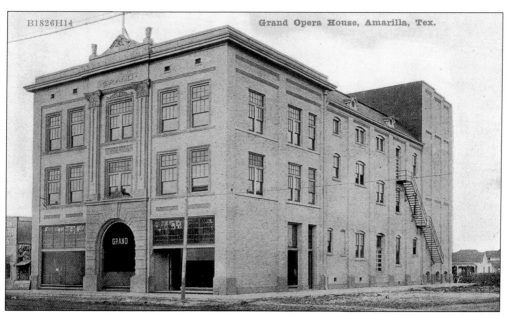

GRAND OPERA HOUSE. This is one of several different postcards on which Amarillo was spelled with an "A" at the end instead of the "O." The Grand Opera House was located at the northeast corner of Polk Street and Seventh Avenue. It was built in 1907 and was later renamed Olympic Theater, where it showed movies. (H. G. Zimmerman and Company, 1912.)

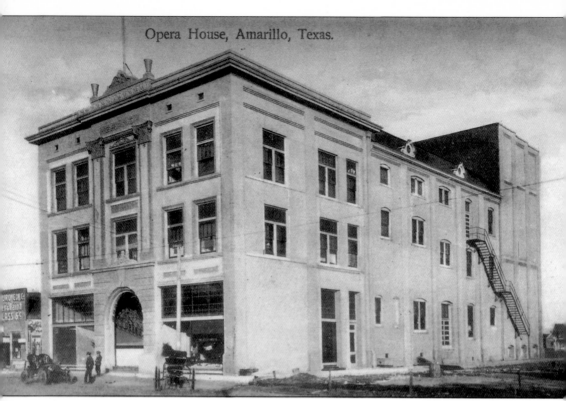

Opera House, Amarillo, Texas.

OPERA HOUSE. The Grand Opera House burned down on Thanksgiving Day in 1919. The building on the left is the Palo Duro Construction Company, which sold wallpaper, paints, and glass. (A. M. Simon, *c.* 1910.)

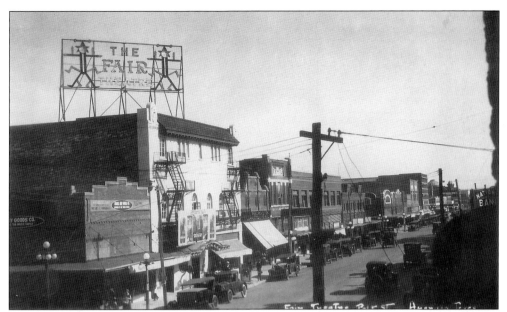

THE FAIR THEATRE, POLK STREET. Looking south on Polk Street is the Fair Theatre that was between Fifth and Sixth Avenues. On the left side of the theatre is Adams Dry Goods Company. On the right edge of this *c.* 1921 card one can see the sign for National Bank of Commerce at Fifth Avenue and Polk Street.

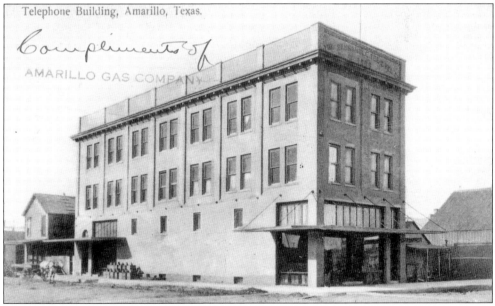

TELEPHONE BUILDING. "Compliments of Amarillo Gas Company" was written and rubber stamped on the front of the card. The building was located at the northwest corner of Sixth Avenue and Taylor Street. The original telephone company was named The Panhandle Telephone and Telegraph Company. It was later renamed the Amarillo Telephone and Telegraph Company. The building was constructed in 1908 and housed the Amarillo Telephone Exchange. The top of the building displays the words "The Panhandle Tel & Tel Co 1908." The building has since been demolished. (The Nickel Store, 1910.)

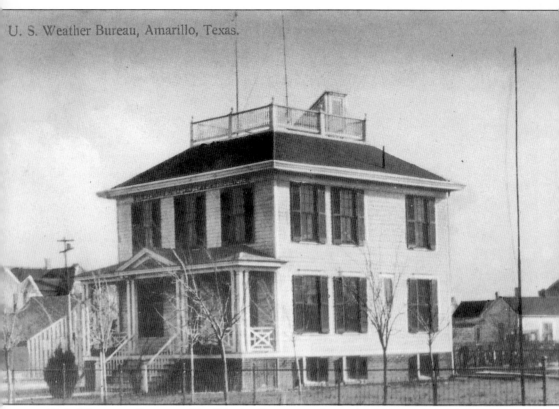

U.S. WEATHER BUREAU. The Weather Bureau was located at 200 East Seventh Avenue on the southeast corner of Taylor Street. It had flagpoles mounted on the roof, and the company would hoist different colors and shapes of flags to indicate what the weather was going to be like for the next day. (A. M. Simon, *c.* 1910.)

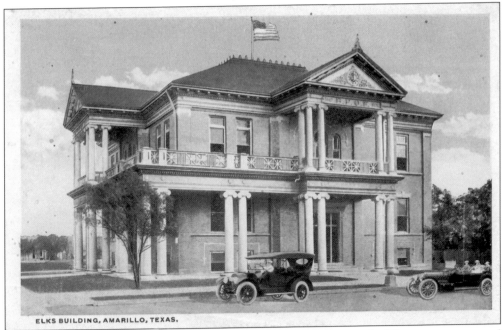

ELKS BUILDING, AMARILLO, TEXAS.

ELK'S BUILDING. This was a popular spot for weekend dances. This building was constructed in 1909 on Fillmore Street between Fifth and Sixth Avenues. It faced the old Potter County Court House. It was demolished in the 1950s, and the new Potter County Courthouse was constructed on this location. (C. T. American Art, 1918.)

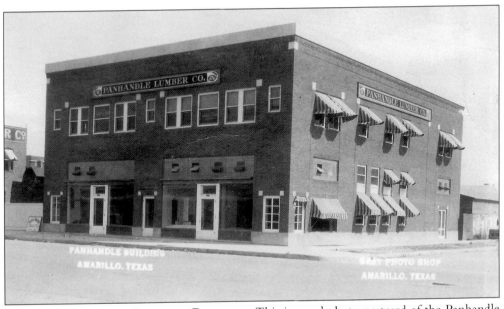

PANHANDLE LUMBER COMPANY BUILDING. This is a real photo postcard of the Panhandle Lumber Company, which was built about 1914 at 123 West Sixth Avenue. The wholesale and paint department offered "quality and service, anything in the building line." On the left side of the building is a sign that reads, "Geo. Parr Contractor Phone 1204." (Gray Photo Shop, c. 1920.)

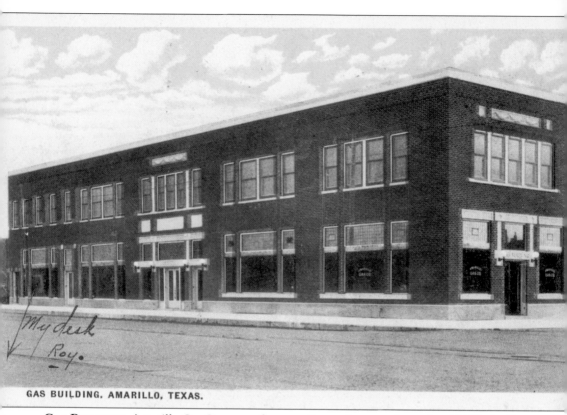

GAS BUILDING, AMARILLO, TEXAS.

GAS BUILDING. Amarillo Gas Company for manufactured gas was located at 301 Taylor Street and was built in 1922. This building was later torn down, and a six-story structure was then built. This later became Pioneer Natural Gas and then Energas. (Commercialchrome, 1930.)

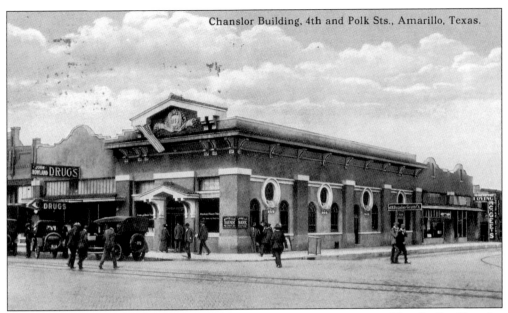

Chanslor Building, 4th and Polk Sts., Amarillo, Texas.

CHANSLOR BUILDING, FOURTH (AVENUE) AND POLK STREETS. The R. L. Chanslor Building, located at Fourth Avenue and Polk Street on the southwest corner, was built in 1914. This was the home of Amarillo Bank and Trust, and in 1935 it was acquired by the First National Bank. Later this building was home to the Silver Grill. To the left is John Rowland Drugs. (The Nickel Store, 1916.)

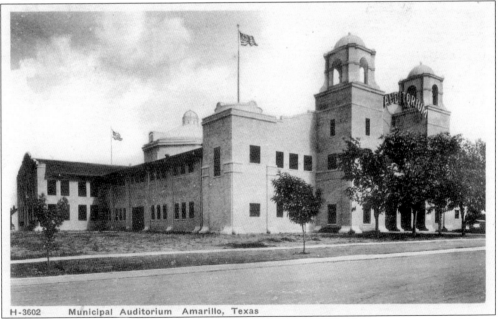

H-3602 Municipal Auditorium Amarillo, Texas

MUNICIPAL AUDITORIUM. The Amarillo Municipal Auditorium was located in the 500 block of South Buchanan Street and was built in 1923. It was the location of the original house of H. B. Sanborn and once housed a library. There were concerts, operas, and theater productions here. The auditorium was torn down in the 1960s to build the Amarillo Civic Center. (Fred Harvey, *c.* 1925.)

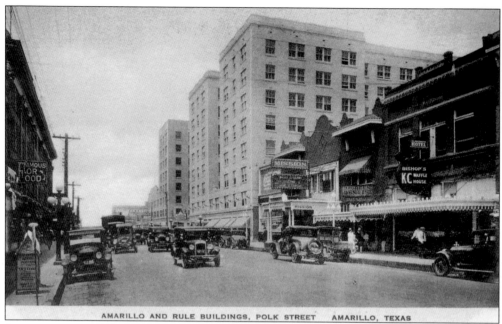

AMARILLO AND RULE BUILDINGS, POLK STREET AMARILLO, TEXAS

AMARILLO AND RULE BUILDINGS, POLK STREET. This is a view looking north on Polk Street. In the center of the card are the Amarillo and Rule Buildings. The Rule Building was constructed in 1927 on the northeast corner. On the right are the KC Waffle House and the Oklahoma Hotel. Farther down the street is the Mission Theater. At the far end of the street is the Amarillo Ice Company. On the left is the Famous For Food Restaurant, which was in the south end of the Amarillo Hotel. (City Drug Store, *c.* 1930.)

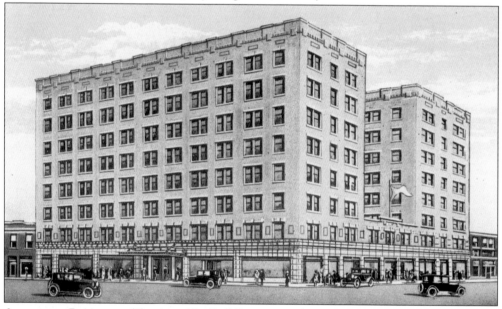

AMARILLO BUILDING. The Amarillo Building was at the intersection of Third Avenue and Polk Street, on the southeast corner, and was constructed in 1925 with only one tower on the north end. The second tower was built in 1926. It still stands today and is named Mesa Two. (McBride News Agency, *c.* 1940.)

44

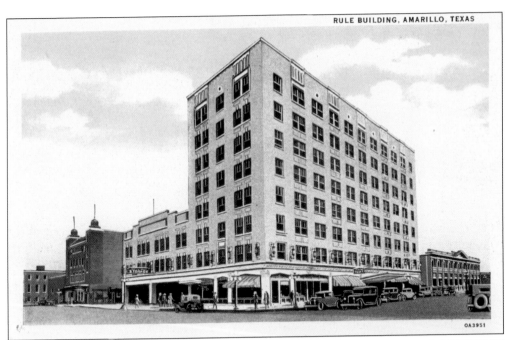

OA3951

RULE BUILDING. The Rule Building was on the northeast corner of Third Avenue and Polk Street and was built in 1927. It was constructed and named for W. S. Rule, who was an estate manager for H. B. Sanborn, the father of Amarillo. It was the headquarters for Southwestern Public Service until 1971 and is still standing today. (McBride News Agency, *c.* 1940.)

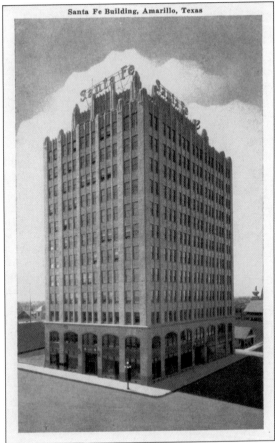

Santa Fe Building, Amarillo, Texas

SANTA FE BUILDING. Located at 900 Polk Street and built in 1930, the Santa Fe Building has been called the king of Polk Street. It was a twin tower, 14-story building that held the regional offices of the railroad. The Santa Fe Railroad no longer resides in this building. In 1995, it was bought by Potter County. In 2000, after extensive remodeling, it opened as offices of Potter County. The structure still stands today. (Graycraft, *c.* 1930.)

45

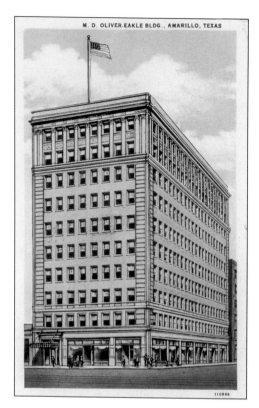

M. D. OLIVER-EAKLE BUILDING. Melissa Dora Oliver-Eakle constructed this 10-story office building in 1927 on the southwest corner of Sixth Avenue and Polk Street. It is considered to be the first skyscraper in Amarillo and has been known as the Barfield building since 1947. (McBride News Agency, c. 1930.)

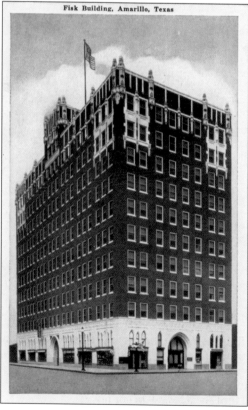

FISK BUILDING. This card is of the 11-story Fisk Medical and Professional Arts Building at 724 Polk Street. It was built in 1928 by Charles Fisk. Amarillo Bank and Trust had offices on the ground floor. Later it merged with the First National Bank. The building still stands today. (Graycraft Card Company, c. 1940.)

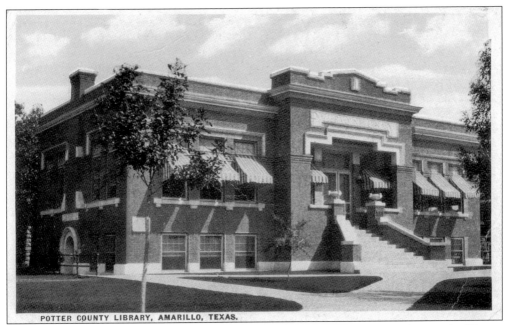

POTTER COUNTY LIBRARY, AMARILLO, TEXAS.

POTTER COUNTY LIBRARY. On the building above the front doors are the words, "Potter County Library." The Potter County Library is at the intersection of Fifth Avenue and Taylor Street. It was built in 1922 and was the first county library in Texas to have its own building. The library moved to the east wing of the municipal auditorium in 1940. The building is still standing today. (Commercialchrome, *c.* 1924.)

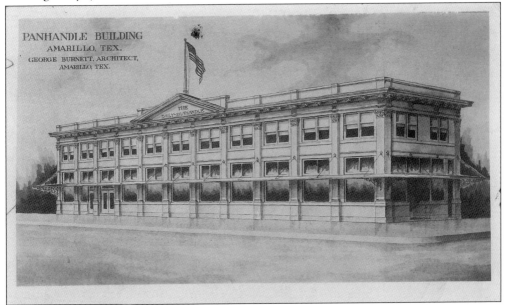

PANHANDLE BUILDING
AMARILLO, TEX.
GEORGE BURNETT, ARCHITECT,
AMARILLO, TEX.

THE DAILY–PANHANDLE BUILDING. "George Burnett, Architect, Amarillo, Tex." is written on the front of this *c.* 1910 postcard. At the top are the words "The Daily–Panhandle." This was the building that housed the *Daily–Panhandle*, which was Amarillo's first daily newspaper to last for any length of time. The structure was built in 1906 and located at the intersection of Third Avenue and Taylor Street.

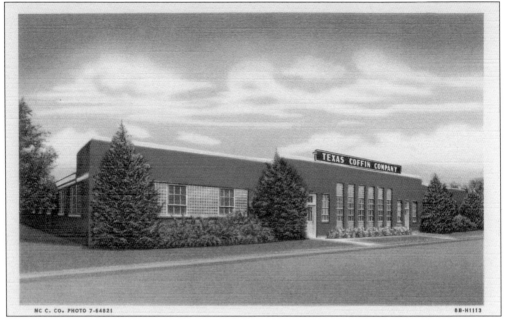

TEXAS COFFIN COMPANY. The Texas Coffin Company's location here was at 810–820 West Fifth Avenue. In 1937, it was located at 316 North Osage Street. In 1938, it moved to the West Fifth Avenue location; around 1974, it moved to 1101 Fritch Highway. (Curteich, 1948.)

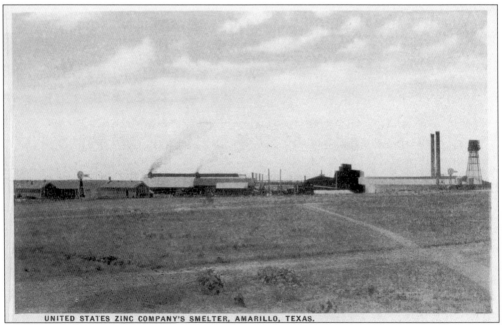

UNITED STATES ZINC COMPANY'S SMELTER. As a result of an abundant and cheap gas supply, a smelter was built in 1923. Railroad cars full of ore from mines were shipped here to be refined into zinc. When it first opened, it was named American Smelting and Refining Company (ASARCO). It closed in 1975. (Commercialchrome, *c.* 1925.)

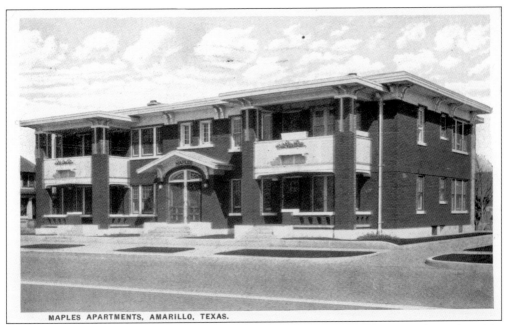

MAPLES APARTMENTS, AMARILLO, TEXAS.

MAPLES APARTMENTS. Constructed about 1920, the Maples Apartments were located at 208–210 West Tenth Avenue in the commercial district area, which meant they were overwhelmed by businesses in the area. The building has since been demolished. (Commercialchrome, 1926.)

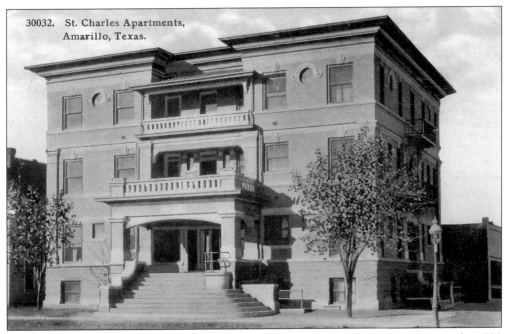

30032. St. Charles Apartments, Amarillo, Texas.

ST. CHARLES APARTMENTS. The St. Charles Apartments building was constructed at 700 Taylor Street in 1911. This location was right in the middle of the downtown business district. The apartments closed in 1932 and were later demolished due to commercial buildings that forced them out. Notice the gas streetlight in the bottom right corner of the 1912 card.

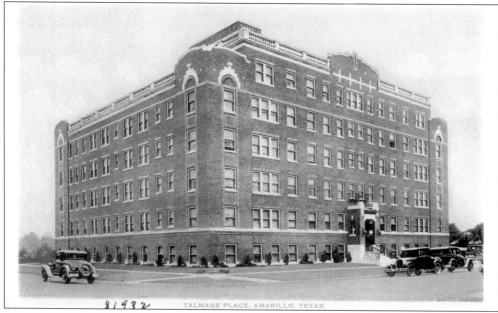

81932 TALMAGE PLACE, AMARILLO, TEXAS.

TALMAGE PLACE. The Talmage Place was a six-story apartment building that was constructed in 1927 at Fourteenth Avenue and Van Buren Street. It had 60 apartments and was built by rancher and oilman H. E. Smith. It is still in operation today as a retirement community building, which is part of Park Central Retirement Community. (Detroit Publishing Company, c. 1930.)

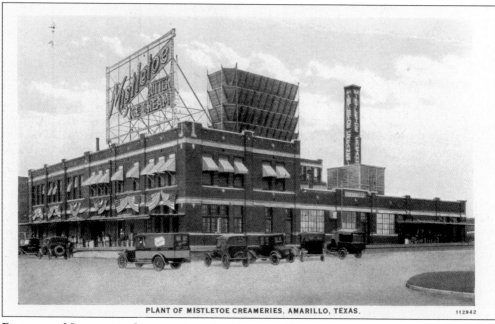

PLANT OF MISTLETOE CREAMERIES, AMARILLO, TEXAS. 112942

PLANT OF MISTLETOE CREAMERIES. As shown in this c. 1927 card, the plant was located at 609 South Grant Street and was built in 1917. It started in 1920 as Mistletoe Creamery, and before then it was known as the Nissley Creamery Company. The company also sold butter and ice cream. It became Borden's in 1928. The building is still in use today by H&R Foods.

AMARILLO TEA AND COFFEE COMPANY. This 1908 real photo postcard features an early Tea and Coffee Company horse and buggy. On the side it advertised, "Choice Teas, Coffee, Spices & Extracts." The card is labeled "George C. Bennett," as he worked for the company.

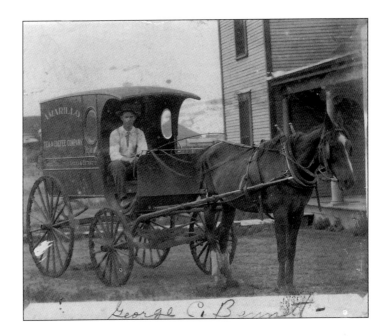

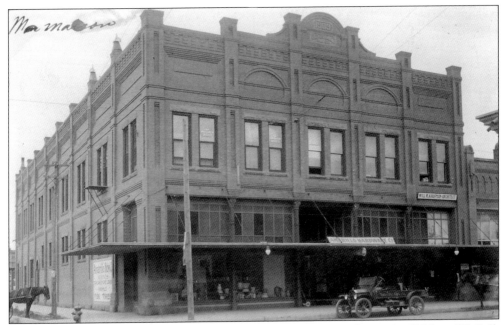

AMARILLO HARDWARE COMPANY. It started business as a retail store in 1904 at 403 Polk Street. This building, located at 516–518 South Polk Street, is labeled "1903 Oliver Eakle Block" at the top on the front of the building, also known as the Eakle Building. This is where Amarillo Hardware was located for its second location. It also sold windmills, wagons, automobiles, hardware, Fisk tires, and more. The business moved to this location in 1912. This building has since been demolished, but the company is still doing business on a national level, with a location on Grant Street. (Unknown publisher, *c.* 1915.)

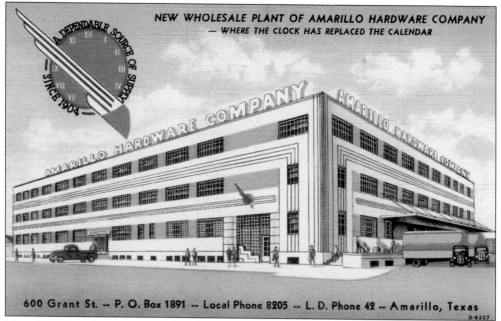

NEW WHOLESALE PLANT OF AMARILLO HARDWARE COMPANY. This structure was built in 1938 at 600 Grant Street. Amarillo Hardware Company started business as a retail store in 1904 at 403 Polk Street. The business now comprises several buildings, occupying all of 500 and 600 Grant Street. (Curteich, 1940.)

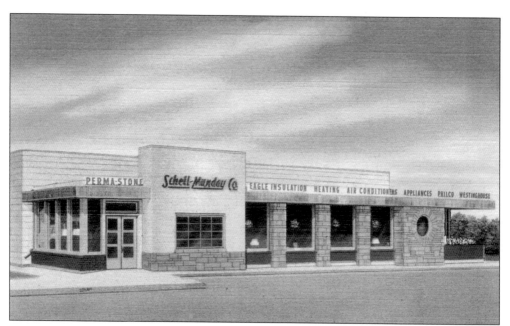

SCHELL-MUNDAY COMPANY. This building was at 1708 West Eighth Street and was built in 1948. It advertised, "Everything for your comfort and convenience." Schell-Munday carried various building supplies and materials such as Perma-Stone, Eagle Insulation, heating, air conditioning, appliances, Philco, and Westinghouse. (Curteich, 1948.)

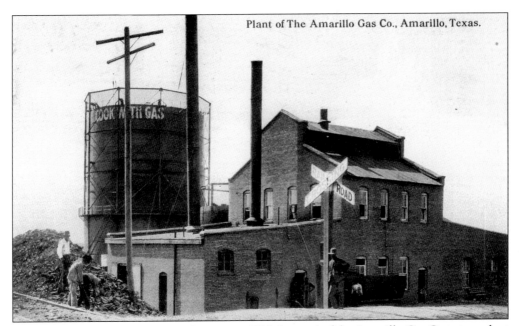

Plant of The Amarillo Gas Co., Amarillo, Texas.

PLANT OF THE AMARILLO GAS COMPANY. This is a card of the Amarillo Gas Company plant at 119 North Tyler Street for manufactured gas and was built in 1907. Their offices were located at 301 Taylor Street. Amarillo Gas Company later became Pioneer Natural Gas, and then later it became Energas. On their big tank tower on the left it reads, "Cook with gas." As evidenced by the railroad crossing sign, it was located next to a railroad track. (The Nickel Store, 1918.)

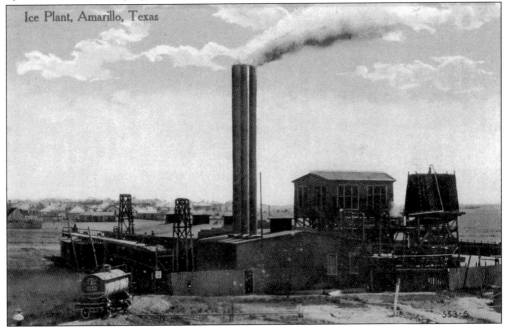

Ice Plant, Amarillo, Texas

ICE PLANT. This card is of the City Ice Company's Ice Plant, which was located at 203 Monroe Street. It supplied a lot of ice to households since this was before refrigeration, and it also supplied a lot to the railroads. Back then, everybody needed blocks of ice to try to keep things cold. This later became known as Amarillo Ice Company. (Fred Harvey, c. 1920.)

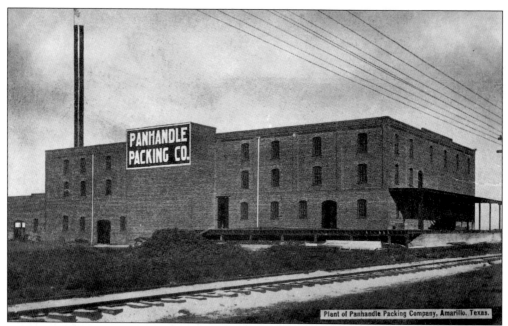

Plant of Panhandle Packing Company, Amarillo, Texas.

PLANT OF PANHANDLE PACKING COMPANY. This card is of the Panhandle Packing Company plant, which was located at 2900 East Third Avenue east of the city limits near Western Stockyards. It was built in 1909 and was a packing plant for both beef and pork. It closed in 1913. In 1930, Pinkney Packing Company started. (Joiner Printing Company, *c.* 1910.)

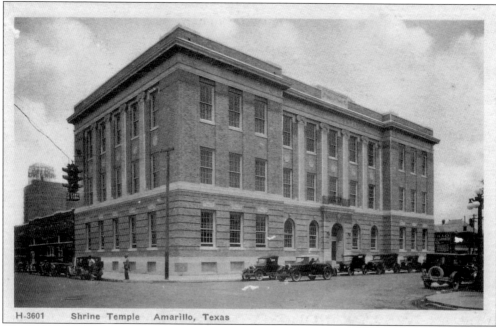

H-3601 Shrine Temple Amarillo, Texas

SHRINE TEMPLE. This card is of the three-story brick building of the Shrine Temple, Kiva Temple, and/or Masonic Temple. It was located at Fifth Avenue and Fillmore Street and was built in 1924. On the left side one can see the sign for the Herring Hotel. The building still stands today. (Fred Harvey, *c.* 1930.)

54

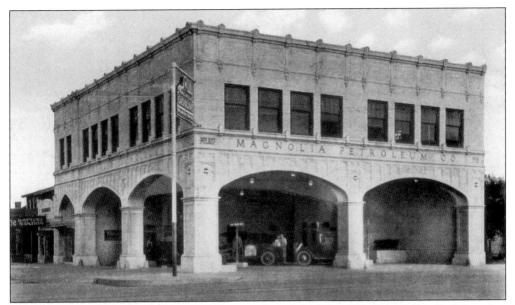

MAGNOLIA PETROLEUM COMPANY. This card is of the Magnolia Petroleum Building that was located at Ninth Avenue and Polk Street and was constructed in 1919. The sign on the pole at the corner of the building reads, "Magnolia Gasoline." Originally it was a gas station and garage on the ground floor with offices upstairs. The building was later converted into all offices and still stands today. (Commercialchrome, *c.* 1920.)

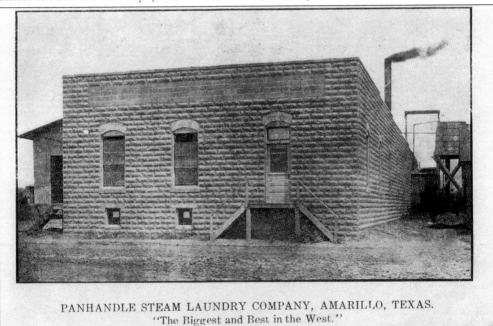

PANHANDLE STEAM LAUNDRY COMPANY, AMARILLO, TEXAS.
"The Biggest and Best in the West."

PANHANDLE STEAM LAUNDRY COMPANY. "The Biggest and Best in the West" is written on the front of this 1908 card for the business whose motto is "The Finest Equipped Plant in the Southwest." This building was constructed in 1907 and was located at 201 South Pierce Street. The company later became known as Panhandle Laundry and Dry Cleaning and is still in business at this location today.

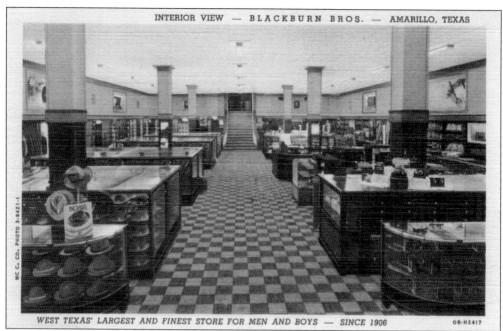

WEST TEXAS' LARGEST AND FINEST STORE FOR MEN AND BOYS — SINCE 1906

INTERIOR VIEW—BLACKBURN BROS. "West Texas' largest and finest store for men and boys—since 1906" is written on the front of this card. It was the home of Hart, Schaffner, Marx and Hickey-Freeman clothes and Stetson and Dobbs hats. This Blackburn Brothers store was built in 1924 at 810 Polk Street and remained open here until 1981. (Curteich, 1940.)

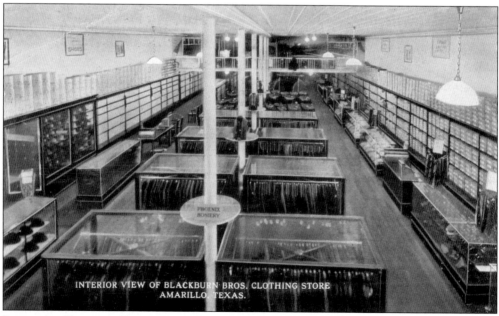

INTERIOR VIEW OF BLACKBURN BROS. CLOTHING STORE
AMARILLO, TEXAS.

INTERIOR VIEW OF BLACKBURN BROS. CLOTHING STORE. On the first pole, the sign reads, "Phoenix Hosiery." This was the third location for Blackburn Brothers. (The Nickel Store, 1920.)

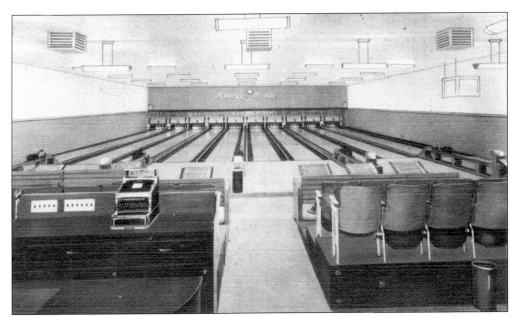

PEERLESS LANES. Built in 1946 at 805 Harrison Street, Peerless Lanes was owned and operated by H. L. Mcminn and Ted Buccola. It had 10 lanes. On the back of this card it reads, "West Texas Finest Alleys. Where Bowlers Gather for Pleasant Relaxation and a Tasty Snack before, during and after their Games." The business closed in 1955. (Curteich, 1946.)

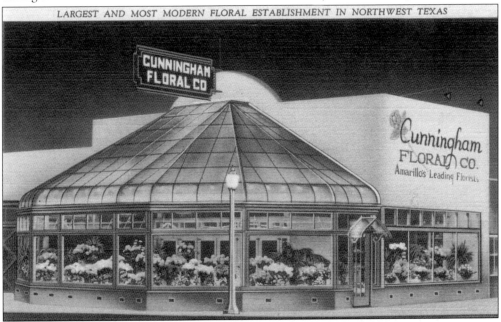

CUNNINGHAM FLORAL COMPANY. "Largest and most modern floral establishment in northwest Texas" is written on the front of this card. On the back it reads, "Amarillo's Leading Florists. With greenhouses and display exhibits representing approximately 15,000 square feet of glass, a very complete selection of finest flowers and decorative plants is assured at all times. Wholesale and retail. Expert floral designing service. Member, Floral Telegraph Delivery Association. Visitors always welcome." Built in 1922, this structure is now a nightclub. (Curteich, 1937.)

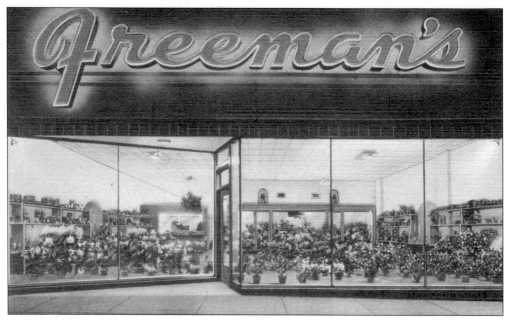

FREEMAN'S FLOWERS. This card is of Freeman's Flowers at 1810 Washington Street, which was built in the mid-1940s. The Freemans started in the flower business in 1938 and offered complete personalized service in their ultramodern, air-conditioned flower shop. They closed this store in 1965, and it was demolished later for Interstate 40. (Curteich, 1948.)

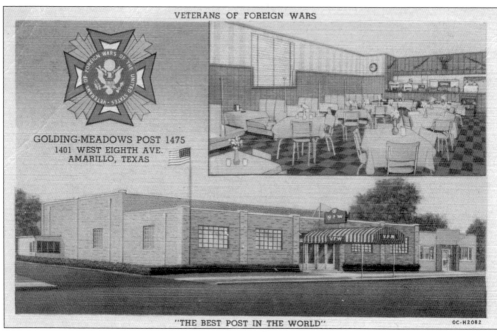

VETERANS OF FOREIGN WARS. "Golding–Meadows Post 1475" is written on the front of this card. Still standing today, the VFW at 1401 West Eighth Avenue has meeting rooms and serves as a club and dance hall. This particular card was sent out to advertise their annual tacky dance. (Curteich, 1950.)

FIRST NATIONAL BANK. This *c.* 1950 card shows the 10-story First National Bank building at Eighth Avenue and Tyler Street. Founded in 1889, First National was the oldest bank in Amarillo. This structure, built in 1950, was the first bank building not constructed on Polk Street. Wagners Jewelers was on the left side of the building.

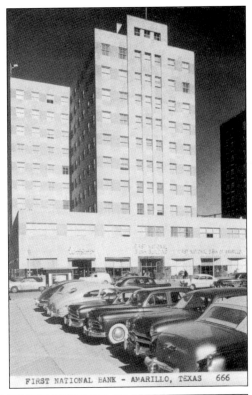

FIRST NATIONAL BANK - AMARILLO, TEXAS 666

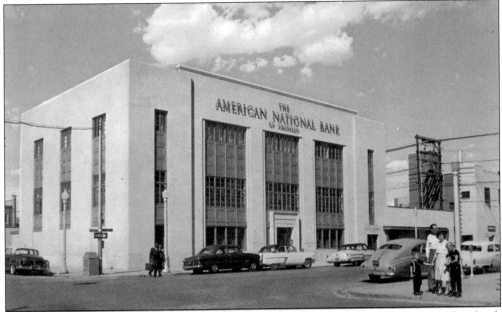

AMERICAN NATIONAL BANK OF AMARILLO. The newest of Amarillo's many fine bank buildings, American National Bank of Amarillo was founded in 1924. It was located at Seventh Avenue and Tyler Street and built in 1952. It was originally named the Guaranty State Bank. The building is still there and is now called the Atrium Plaza. (West Texas News Agency, *c.* 1950.)

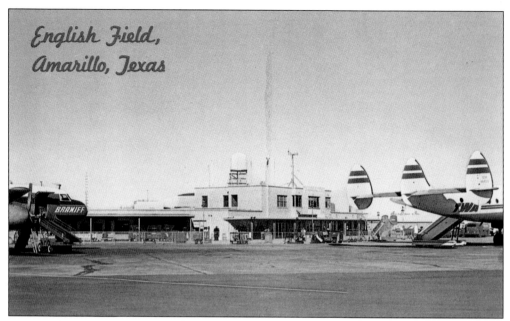

English Field, Amarillo, Texas

ENGLISH FIELD. This modern terminal situated at the hub of the West's all-directional air traffic had modern accommodations, from the smallest private airplane to the largest jet airliners. In this image, a Braniff International Airways prop plane and a TWA prop plane sit on the runway. Passengers had to walk outside to the airplane for boarding either in the front or the rear of the plane. In 1952, the field was renamed Amarillo Air Terminal, and it closed in 1971 when it moved to a new terminal. (Petley Studios, *c.* 1950.)

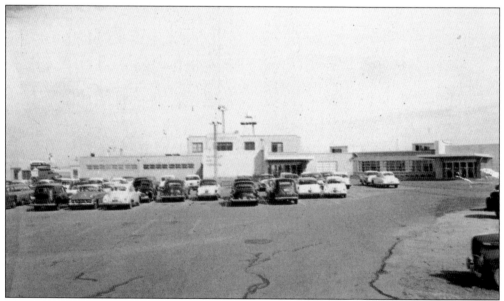

AMARILLO AIR TERMINAL. The new ranch-style air terminal completed in 1954 is one of the most attractive air terminals in the Southwest. Thousands of air passengers were serviced here daily. It was located about 7 miles east of U.S. Highway 60. It closed in 1971 when it was moved to a new terminal that was on the east side of the runway. (Baxtone, *c.* 1955.)

Four

CHURCHES

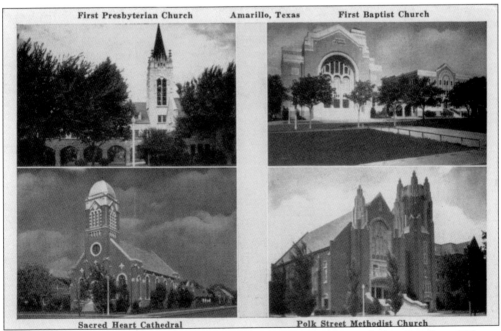

CHURCHES OF AMARILLO, TEXAS. This is a multi-view postcard showing four different churches of Amarillo, Texas. They are First Presbyterian Church, located at Eleventh Avenue and Harrison Street; First Baptist Church, located at Thirteenth Avenue and Tyler Street; Sacred Heart Cathedral, which was previously located at Ninth Avenue and Taylor Street; and Polk Street Methodist Church, located at Fourteenth Avenue and Polk Street. (Graycraft Card Company, *c.* 1940.)

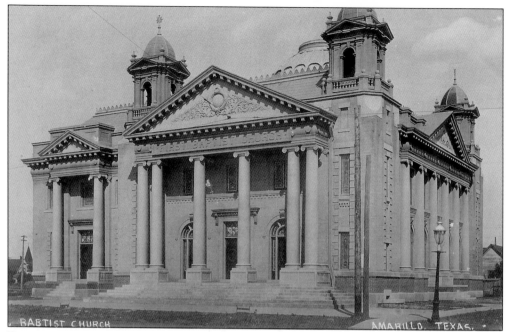

BAPTIST CHURCH. This is a *c.* 1910 real photo postcard of the First Baptist Church. Above the front door is appropriately written, "First Baptist Church." Constructed in 1908, this was the congregation's second church building. It was located at Ninth Avenue and Polk Street and was completely paid for when the congregation moved in. Deacon W. H. Fuqua donated the lot.

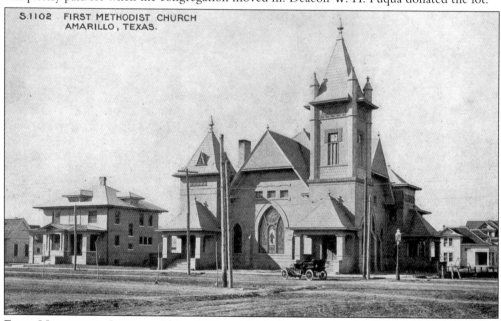

FIRST METHODIST CHURCH. This *c.* 1910 card shows the structure with the name First Methodist Church, which was later changed to Polk Street Methodist Church because the city decided the Methodist churches had to be named after their street names. This one was located at Eighth Avenue and Polk Street and built in 1907. Pastor C. N. N. Ferguson bought the lot personally and gave it to the church. Note the gas streetlight on the right corner of the building.

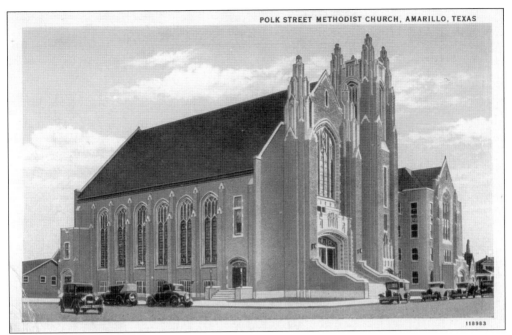

POLK STREET METHODIST CHURCH. This half-million-dollar church and parsonage was located at Fourteenth Avenue and Polk Street and was built in 1928. The First Methodist Church in Dallas was used as a guide for designing this church. (C. T. American, *c.* 1930.)

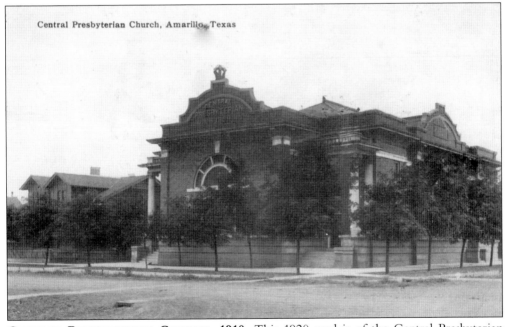

Central Presbyterian Church, Amarillo, Texas

CENTRAL PRESBYTERIAN CHURCH, 1910. This 1920 card is of the Central Presbyterian Church located at Tenth Avenue and Taylor Street. It was built in 1910. The church was originally named First Cumberland Presbyterian Church and it is now called First Presbyterian Church and is located at 1100 Harrison Street.

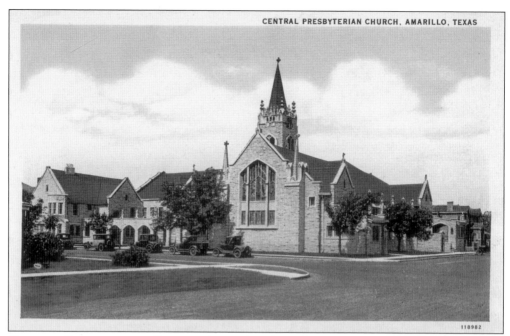

CENTRAL PRESBYTERIAN CHURCH. Located at Eleventh Avenue and Harrison Street, Central Presbyterian Church was built in 1927. Originally named First Cumberland Presbyterian Church, it is now called First Presbyterian Church. (*C. T. American, c.* 1929.)

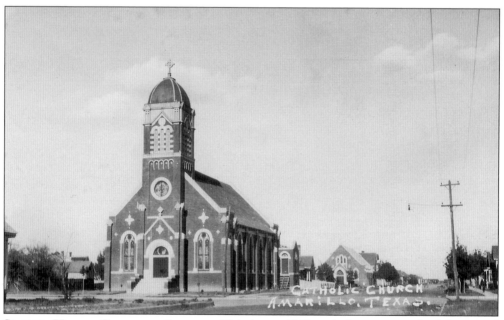

SACRED HEART CATHOLIC CHURCH. This is a *c.* 1920 real photo postcard of the Sacred Heart Catholic Church, which was located at Ninth Avenue and Taylor Street and built in 1916. Amarillo's first Catholic church, it was later renamed Sacred Heart Cathedral and was demolished in 1975.

64

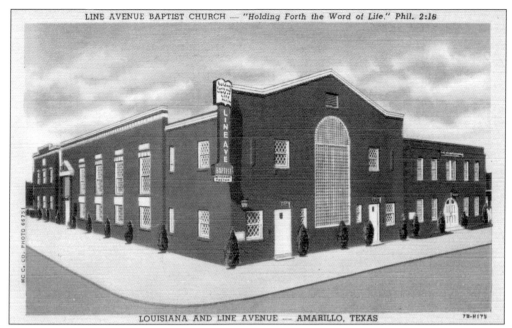

LINE AVENUE BAPTIST CHURCH. The building was constructed in 1933, and the modern church edifice was completed in 1946, when J. W. Sisemore was the pastor. It was renamed Parkview Baptist Church in the mid-1960s and was closed in 1970. (Curteich, 1947.)

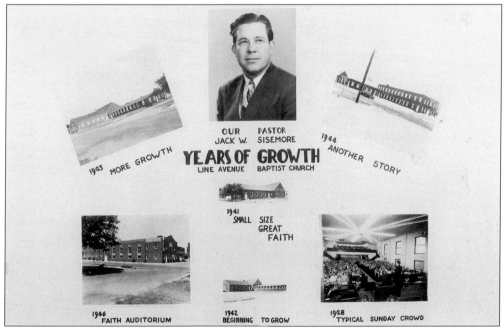

YEARS OF GROWTH FOR LINE AVENUE BAPTIST CHURCH. Written on this *c.* 1948 postcard is the following, "Our pastor Jack W. Sisemore; 1941, small size, great faith; 1942, beginning to grow; 1943, more growth; 1944, another story; 1946 Faith Auditorium; 1948, typical Sunday crowd."

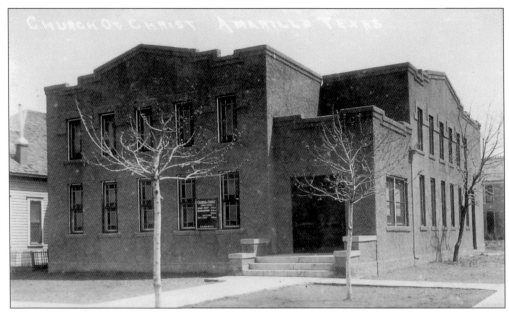

CHURCH OF CHRIST. This 1919 real photo postcard shows the church that was built at Tenth Avenue and Fillmore Street in 1916. This house of worship had plain gospel preaching and good congregational singing. The building has since been demolished.

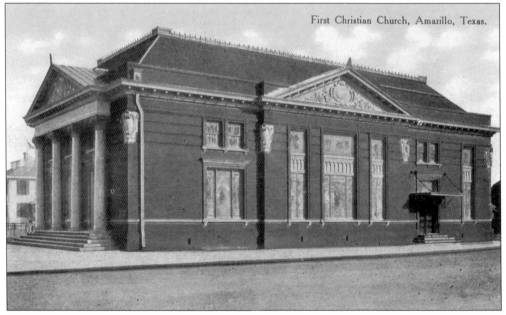

FIRST CHRISTIAN CHURCH. The First Christian Church was located at Eighth Avenue and Taylor Street and was built in 1909. In 1965, the congregation moved to a new church building located in the Wolflin Village area. The building has since been demolished. (The Nickel Store, c. 1910.)

Five

HOTELS AND MOTELS

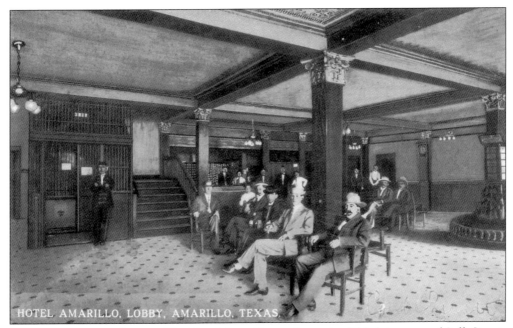

HOTEL AMARILLO, LOBBY. The Hotel Amarillo was located at Third Avenue and Polk Street. Men used to gather in the lobby to sit around and talk. To the left side of the card, an elevator operator stands by to give someone a ride. (The Nickel Store, 1910.)

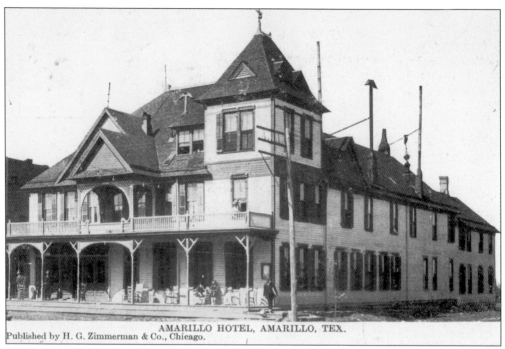

AMARILLO HOTEL. In the original wooden-framed Hotel Amarillo, built in 1889, there were 40 rooms. In 1922, the old hotel was moved to build a new hotel at this location. Then in 1927 the old hotel burned down. (H. G. Zimmerman and Company, 1907.)

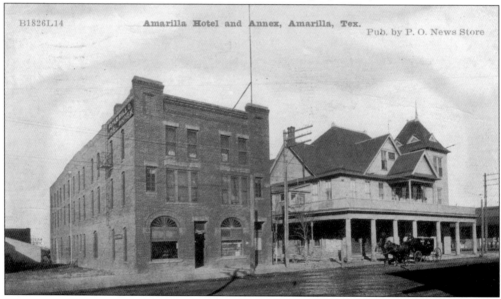

"AMARILLA" HOTEL AND ANNEX. This is one of many postcards where Amarillo is spelled with an A on the end instead of an O. This card shows where the annex was added onto the Hotel Amarillo. The annex was originally brought from old town and was formally the Tremont Hotel. When moved here, it was used as an office building at 304 Polk Street. The annex was later sold and moved to the old Bowery area, which was located around Second Avenue and Lincoln Street. (H. G. Zimmerman and Company, 1907.)

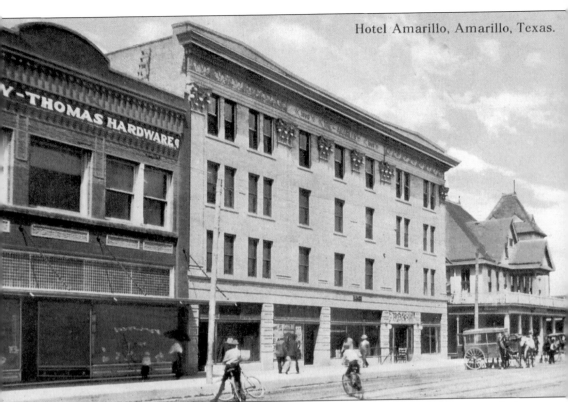

Hotel Amarillo, Amarillo, Texas.

HOTEL AMARILLO. The Hotel Amarillo block is pictured after the annex was removed. A new four-story building was constructed around 1907 where the annex stood. It featured steam heat, electric and gas lighting, hot and cold running water, and an elevator. It had 205 rooms, of which 75 had private baths. Also in 1907, the Morrow Thomas Hardware Company building (left) was constructed. The old original Hotel Amarillo is still there on the far right. (The Nickel Store, *c.* 1910.)

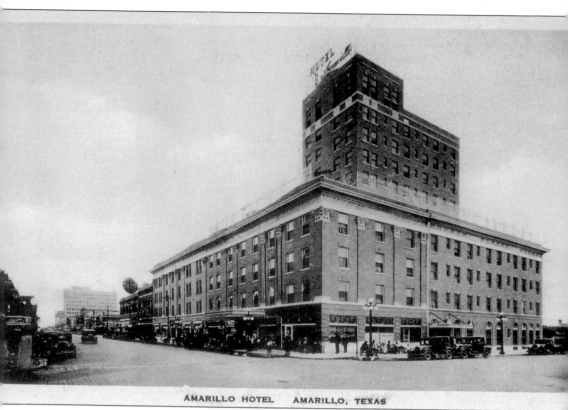

AMARILLO HOTEL AMARILLO, TEXAS

AMARILLO HOTEL TOWER. Seen here is the fourth and final addition to the hotel that was completed in 1927. The original hotel closed in 1965, and the building was later demolished. (City Drug Store, *c.* 1930.)

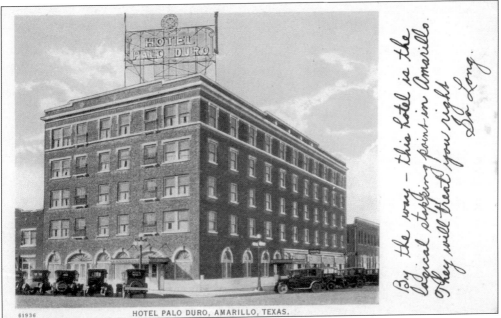

61936 HOTEL PALO DURO, AMARILLO, TEXAS.

HOTEL PALO DURO. Across the street from the Herring Hotel was the Hotel Palo Duro at Third Avenue and Fillmore Street. It was constructed in the early 1920s by Col. C. T. Herring. This hotel has since been demolished. (Commercialchrome, *c.* 1930.)

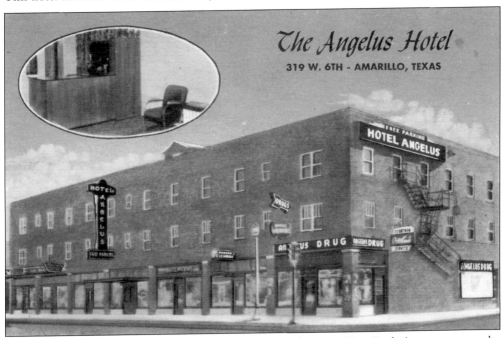

THE ANGELUS HOTEL. Built in the 1920s and located at 319 West Sixth Avenue, two and a half blocks from the center of downtown on U.S. Highway 66 business route, the Angelus Hotel featured 66 clean, modern, and comfortable rooms for "$2 and up" with a free enclosed parking facility for guests. It also housed Angelus Drug, which featured fountain service. (Nationwide Post Card Company, *c.* 1950.)

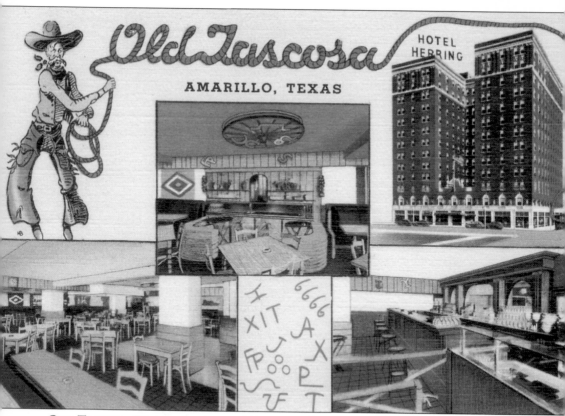

OLD TASCOSA. Dining, dancing, and live entertainment were offered at the Western-themed Old Tascosa nightclub in the basement of the Herring Hotel. When it was built in the 1940s, the Amarillo population was 90,000. (Curteich, 1944.)

HOTEL HERRING. This *c.* 1930 real photo postcard shows the Hotel Herring at 317 East Third Avenue. Built by Col. C. T. Herring in 1928, it was a 14-story hotel that had 600 rooms and baths. Last known as the Herring Plaza Office Building, it is now vacant but still standing.

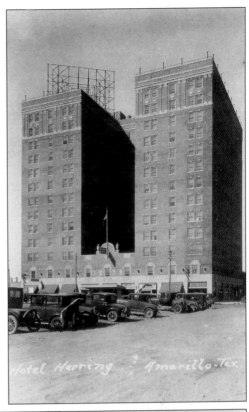

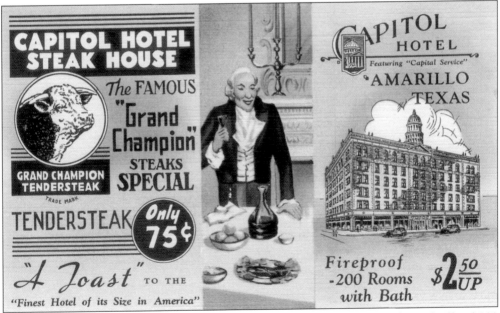

CAPITOL HOTEL STEAK HOUSE. "Featuring Capital Service," the Capitol Hotel offered 200 fireproof rooms for $2.50 and up. The steaks were only 75¢. The very elegant six-story hotel was located at Fourth Avenue and Pierce Street. Built in 1928, it closed in 1971 and was demolished in 1977. (Curteich, 1935.)

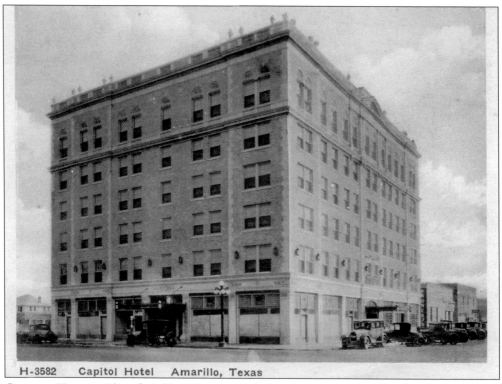

H-3582 Capitol Hotel Amarillo, Texas

CAPITOL HOTEL. A lot of marble and ornate light fixtures were used during the construction of the Capitol Hotel. The hotel was originally built with a dome on the top. This view shows the hotel without the dome on top, which was removed in the late 1930s. (Fred Harvey, *c.* 1940.)

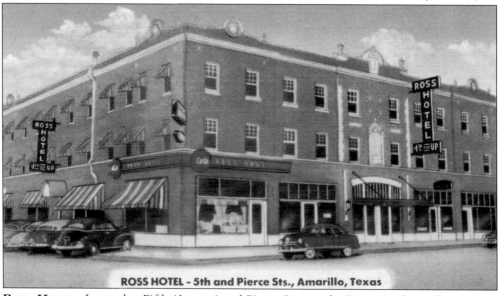

ROSS HOTEL - 5th and Pierce Sts., Amarillo, Texas

ROSS HOTEL. Located at Fifth (Avenue) and Pierce Streets, the Ross Hotel was three stories tall. Its list of selling points included "fireproof, popular prices, downtown, strictly modern, drug store, barber shop, dining room, and a tailor shop." It was built in 1927, closed in 1984, and was demolished shortly thereafter. (Advertising Pencil Company, *c.* 1950.)

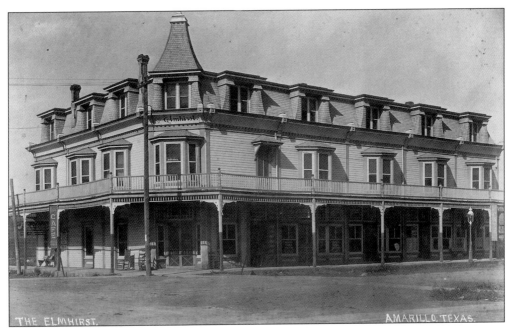

THE ELMHIRST HOTEL. This *c.* 1905 real photo postcard shows the Elmhirst Hotel, which was built in 1901 at Fifth Avenue and Taylor Street. Dr. John Bedford had an office upstairs, and it also had a café. It burned down in 1929, and five people died in the fire. This is the location of the current federal building.

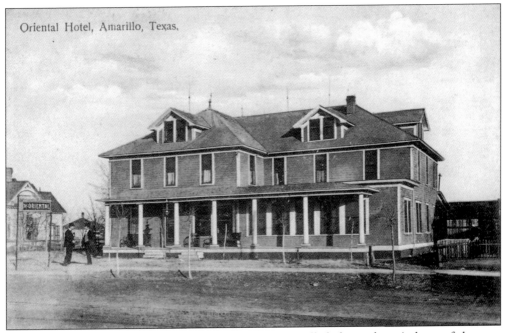

ORIENTAL HOTEL. Note that there are no shades installed above the windows of the new Oriental Hotel. Built in 1909, it was two and a half stories tall and was located at 205 Lincoln Street in the old Bowery area that was located around Second Avenue and Lincoln Street. (The Nickel Store, *c.* 1910.)

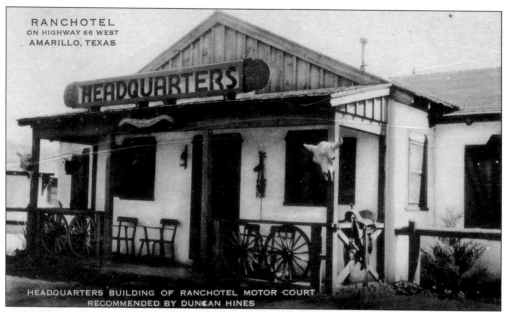

RANCHOTEL ON U.S. HIGHWAY 66 WEST. The front of this card reads, "Headquarters Building of Ranchotel Motor Court. Recommended By Duncan Hines." It was sometimes spelled "Ranch-o-tel." Motor courts were very popular across America. (Artvue Postcard Company, *c.* 1930.)

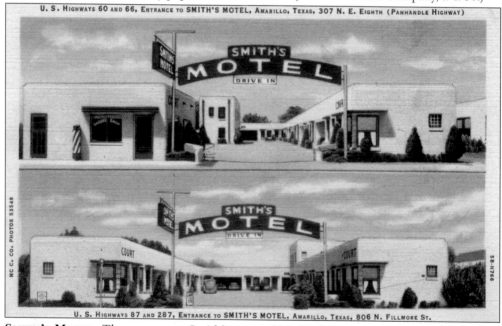

SMITH'S MOTEL. The entrance to Smith's was on U.S. Highways 60 and 66 at 307 Northeast Eighth Avenue (Panhandle Highway). Built in 1939, it was the first place in Amarillo to use the "motel," short for motor hotel, designation. Owned by H. E. Smith, it was the tourist center of Northwest Texas, advertising "100 percent insulation, brick construction and fire protection, innerspring mattresses, private baths and finest apartments at moderate rates." The motel had its own barbershop and was adjacent to a drugstore and Lincoln Park. A second entrance was on U.S. Highways 87 and 287 at 806 North Fillmore Street. (Curteich, 1945.)

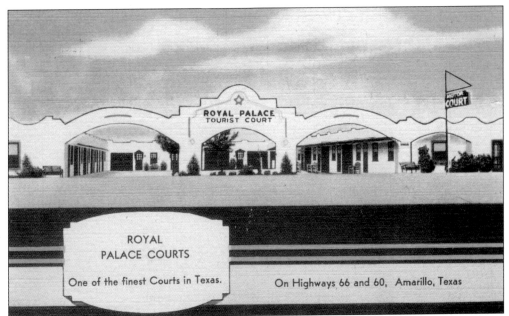

ROYAL PALACE COURTS. "One of the Finest Courts in Texas," Royal Palace Courts on Routes 66 and 60 advertised, "18 apartments. Private baths and toilets. Simmons beds. Beautyrest mattresses. Reasonable rates. Personal service." Built in 1938, the motor court was on 1409 Northeast Eighth Street. (MWM Color Litho, 1947.)

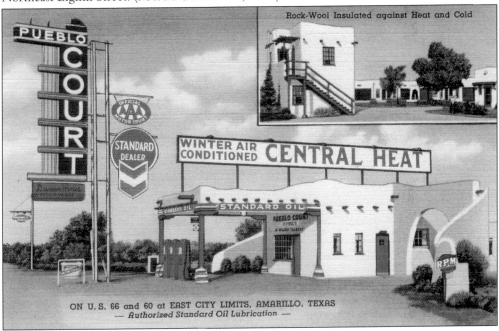

PUEBLO COURT. Advertising "Rock-Wool Insulated against Heat and Cold," Pueblo Court was located on U.S. Highways 66 and 60 at East City Limits. "Authorized Standard Oil Lubrication" is written at the bottom of this card. Pueblo Court touted that it combined "ultramodern accommodations with the charm of early Pueblo Indian architecture and furnishings. Duncan Hines recommended." J. Wilkie Talbert, was the owner-manager. (Curteich, 1940.)

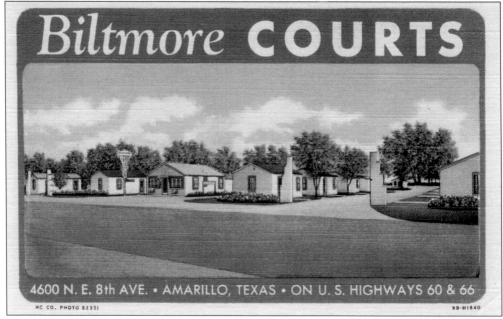

BILTMORE COURTS. Located at 4600 Northeast Eighth Avenue on Routes 60 and 66, the Biltmore Courts, built in 1945, were advertised as having "private tiled baths, innerspring mattresses in modern air-conditioned, insulated cabins. Refrigeration. Kitchenettes available. Reasonable rates. Nine-minute drive from downtown Amarillo." (Curteich, 1949.)

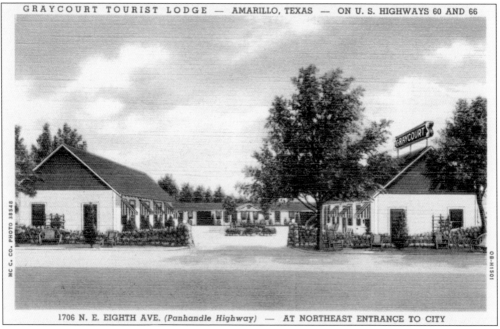

GRAYCOURT TOURIST LODGE. This lodge was located on U.S. Highways 60 and 66 at 1706 Northeast Eighth Avenue (Panhandle Highway) and offered "strictly modern accommodations at reasonable rates. Quiet and comfortable. Private tile bath, furnace heat. Every room insulated." (Curteich, 1940.)

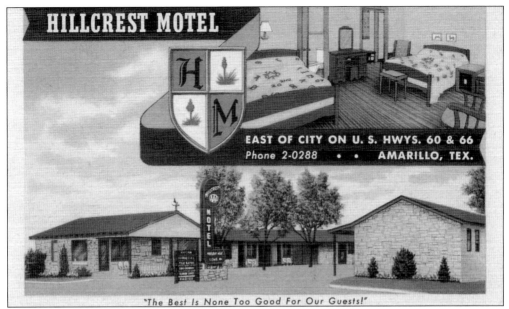

HILLCREST MOTEL. Recommended by AAA, the Hillcrest Motel was located east of the city on U.S. Highways 60 and 66 at 3017 Northeast Eighth Avenue, and the motel's phone number was 2-0288. Accommodations were described as "twelve modern units with airfoam mattresses, tile baths, radios, panel-ray heating and air conditioning, and conveniently located—10-minute drive to downtown business district." (Curteich, 1951.)

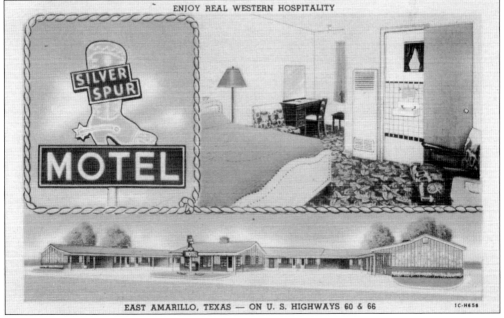

SILVER SPUR MOTEL. At the top of this card it reads, "Enjoy real Western hospitality." Mr. and Mrs. L. V. and Jewell Stafford were the owners of the Silver Spur, located at 4011 Northeast Eighth Avenue on U.S. Highways 60 and 66. It offered 16 deluxe units featuring Franciscan-style furnishings, wall-to-wall carpeting, air conditioning, circulating heat, and tile baths, and it was a five-minute drive to the downtown business district. (Curteich, 1951.)

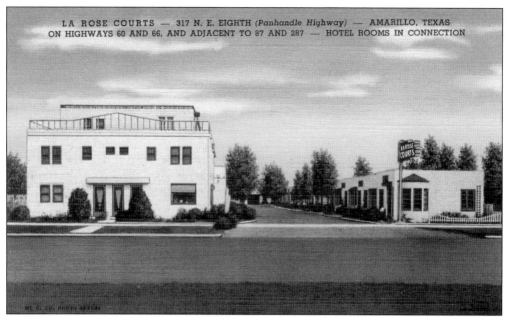

LA ROSE COURTS — 317 N. E. EIGHTH *(Panhandle Highway)* — AMARILLO, TEXAS
ON HIGHWAYS 60 AND 66, AND ADJACENT TO 87 AND 287 — HOTEL ROOMS IN CONNECTION

LA ROSE COURTS. Located at 317 Northeast Eighth Avenue (Panhandle Highway) on U.S. Highways 60 and 66 and adjacent to 87 and 287 with hotel rooms in connection, La Rose Courts was quiet, adjacent to excellent restaurants, and only five minutes from the courthouse. (Curteich, 1943.)

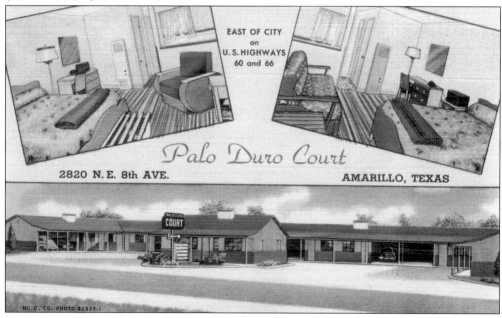

EAST OF CITY
on
U. S. HIGHWAYS
60 and 66

Palo Duro Court

2820 N. E. 8th AVE. AMARILLO, TEXAS

PALO DURO COURT. Featured on this card is "Amarillo's newest and finest court, offering you distinctive furnishings in a distinctive atmosphere, air-conditioned units, Beautyrest mattresses, circulating wall furnaces and tiled baths make this Amarillo's preferred lodging. 10-minute drive to business district. Reasonable rates." Located at 2820 Northeast Eighth Avenue, east of the city on U.S. Highways 60 and 66, Palo Duro Court was recommended by AAA and was built in 1952. (Curteich, 1950.)

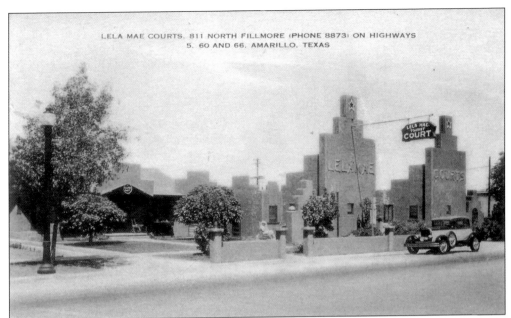

LELA MAE COURTS, 811 NORTH FILLMORE (PHONE 8873) ON HIGHWAYS 5, 60 AND 66, AMARILLO, TEXAS

LELA MAE COURTS. Lela Mae Courts was built in 1926, about five years after Route 66 came through town. Located at 811 North Fillmore Street (phone 8873) on U.S. Highways 5, 60, and 66, it was owned by Lela Mae Barnum and was one of the city's pioneer tourist courts. It has since been demolished. (Artvue Postcard Company, c. 1930.)

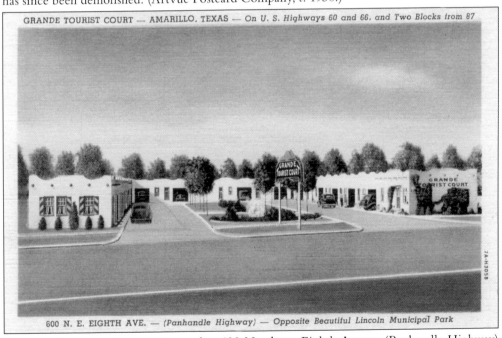

GRANDE TOURIST COURT — AMARILLO, TEXAS — On U. S. Highways 60 and 66, and Two Blocks from 87

600 N. E. EIGHTH AVE. — (Panhandle Highway) — Opposite Beautiful Lincoln Municipal Park

GRANDE TOURIST COURT. Located at 600 Northeast Eighth Avenue (Panhandle Highway) on U.S. Highways 60 and 66 and two blocks from 87 is the Grande Tourist Court, opposite beautiful Lincoln Municipal Park. It offered "completely furnished, ultra-modern tourist rooms and apartments with private tile baths and electric refrigeration at moderate rates. Across the street is shady Lincoln Park with its tennis courts, playgrounds." (Curteich, 1937.)

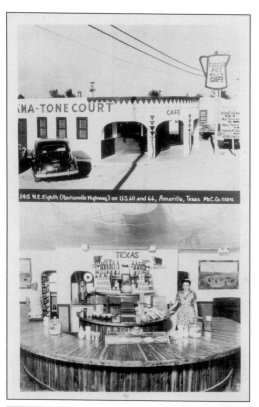

COFFEE POT BILL'S CAFE. Located at the Ama-Tone Court at 2415 Northeast Eighth Avenue (Panhandle Highway) on U.S. Highways 60 and 66, Coffee Pot Bill's Cafe served fried chicken, hot biscuits, steaks and chops, and real coffee. It also offered "health water" and delivered it to any part of the city. In 1945, the building was listed as Ama-Tone Well and Apartments. (McCormick Company, 1946.)

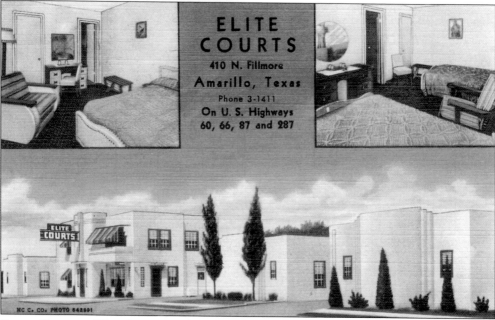

ELITE COURTS. Elite Courts was located on 410 North Fillmore Street (Phone 3-1411) on U.S. Highways 60, 66, 87, and 287. It advertised, "Where elite tourists gather for ultra-modern accommodations, luxurious furnishings, air conditioning, insulation and circulating heat. Convenient location and moderate rates." (Curteich, 1946.)

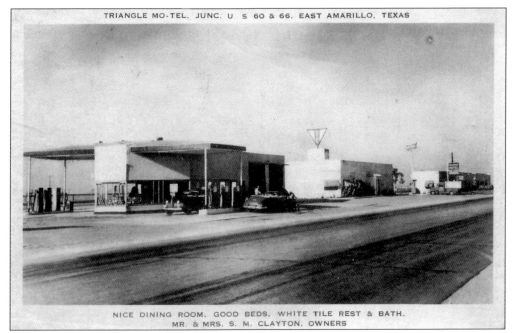

TRIANGLE MO-TEL. JUNC. U S 60 & 66. EAST AMARILLO, TEXAS

NICE DINING ROOM. GOOD BEDS. WHITE TILE REST & BATH.
MR. & MRS. S. M. CLAYTON. OWNERS

TRIANGLE MO-TEL. Located at the junction of U.S. Highways 60 and 66, this motel had a "nice dining room, good beds, white tile rest and bath." It was built in the late 1940s and took its name from the shape of the merge of these highways east of town. Mr. and Mrs. S. M. Clayton were the owners. The motel is currently being renovated. (Artvue Postcard Company, 1949.)

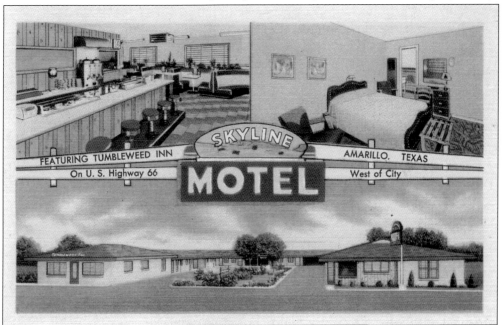

FEATURING TUMBLEWEED INN
On U. S. Highway 66

SKYLINE
MOTEL

AMARILLO, TEXAS
West of City

SKYLINE MOTEL. Built in 1951 and featuring the Tumble Weed Inn, the Skyline Motel was located on U.S. Highway 66, west of the city at 5711 Ninth Avenue, across from Veterans Hospital. Recommended by AAA, the hotel featured 18 ultra-modern units, Franciscan furniture, private tiled baths, panel ray heating, and air conditioning. (Curteich, 1951.)

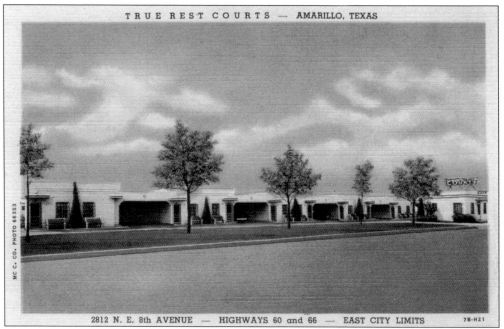

TRUE REST COURTS — AMARILLO, TEXAS

MC C. CO. PHOTO 66353

2812 N. E. 8th AVENUE — HIGHWAYS 60 and 66 — EAST CITY LIMITS

7B-H21

TRUE REST COURTS. Located at 2812 Northeast Eighth Avenue on U.S. Highways 60 and 66, east of city limits, True Rest Courts was built in 1941 and was only a five-minute drive from downtown Amarillo. Its modern accommodations and convenient location make this Amarillo's outstanding tourist haven. (Curteich, 1947.)

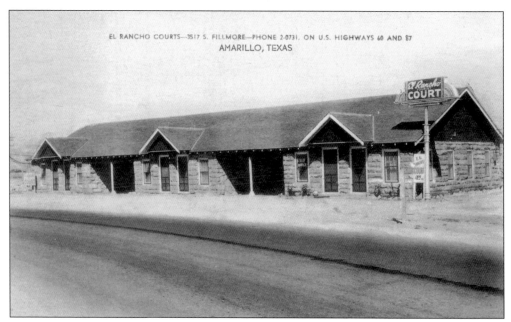

EL RANCHO COURTS—3517 S. FILLMORE—PHONE 2-0731. ON U.S. HIGHWAYS 60 AND 87
AMARILLO, TEXAS

EL RANCHO TOURIST COURT. Built in 1939 and located at 3517 South Fillmore Street (Phone 2-0731) on U.S. Highways 60 and 87, El Rancho Tourist Court had eight units and was a five-minute drive from downtown. The sign out front reads, "El Rancho Court $1.00 and up." (McCormick Company, *c.* 1940.)

Six

RESTAURANTS AND TRUCK STOPS

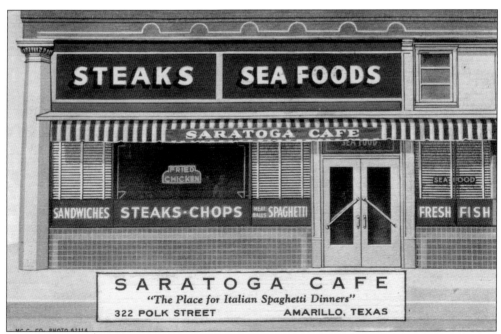

SARATOGA CAFE. Declaring itself as "the Place for Italian Spaghetti Dinners," Saratoga Cafe was located at 322 Polk Street. Dishes included fried chicken, sandwiches, steaks, chops, meatball spaghetti, seafood, and fresh fish. The restaurant opened for business in 1948 and was owned by Bob Dowell. (Curteich, 1947.)

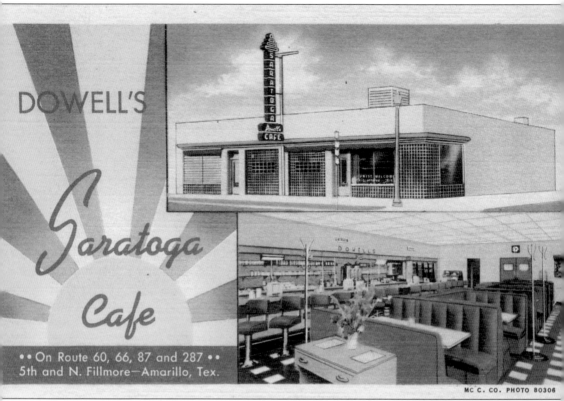

DOWELL'S SARATOGA CAFE. Opened for business around 1949, this Saratoga Cafe location was on U.S. Highways 60, 66, 87, and 287 at Fifth Avenue and North Fillmore Street. It was advertised as "Amarillo's finest eating place, offering you the best foods available in an ultra-modern atmosphere that you will enjoy. Dining rooms available for private parties and banquets." (Curteich, 1949.)

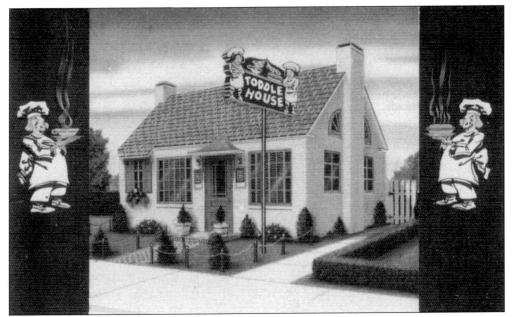

THE TODDLE HOUSE. The two Toddle Houses in town were at 1219 West Tenth Avenue and 614 North East Eighth Avenue (Amarillo Boulevard). They were built around 1955. It was a national restaurant chain specializing in breakfast and open 24 hours a day, seven days a week. The restaurants were inviting in appearance and tried hard to carry out the slogan "as good as the best." (MWM Color Litho, *c.* 1955.)

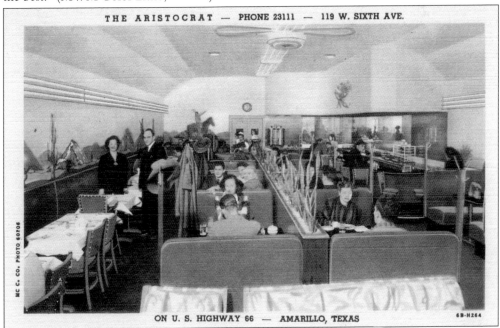

THE ARISTOCRAT. The phone number was 23111, and it was located at 119 West Sixth Avenue on U.S. Highway 66. The back of the card reads, "The Aristocrat is the popular restaurant for discriminating patrons." It had booth service, table service, and counter service. It opened in 1946 and closed in 1957. The building has since been demolished. (Curteich, 1946.)

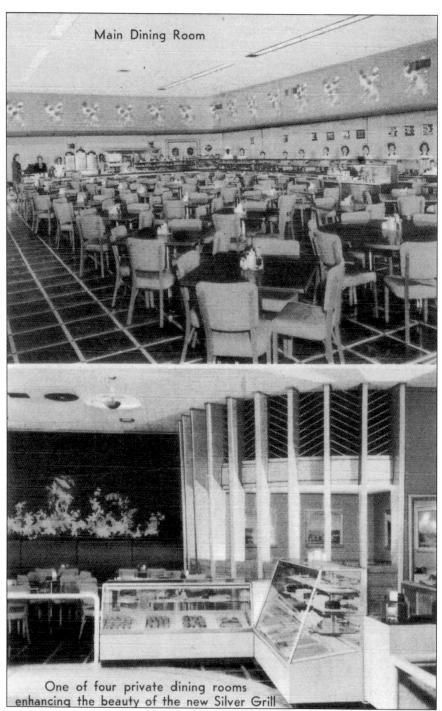

Main Dining Room

One of four private dining rooms
enhancing the beauty of the new Silver Grill

SILVER GRILL. This card shows the main dining room (above) and "one of four private dining rooms enhancing the beauty of the new Silver Grill" (below). The Southwest's finest cafeteria was nationally known for over 30 years and closed in 1972. The 704 Tyler Street location, next door to the Continental bus station, was its third address while in business. (Nationwide Postcard Company, *c.* 1950.)

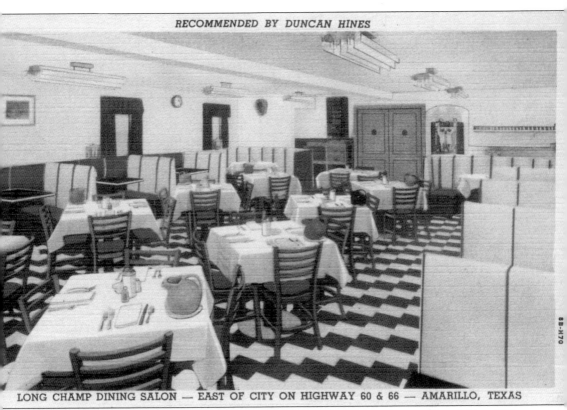

LONG CHAMP DINING SALON — EAST OF CITY ON HIGHWAY 60 & 66 — AMARILLO, TEXAS

LONG CHAMP DINING SALON. Located east of the city on U.S. Highways 60 and 66 at 705 Northeast Eighth Avenue was the Long Champ Dining Salon, which was "recommended by Duncan Hines." Opened in 1945 and specializing in seafood in a spot it touted as "where the Plains meet the sea," Long Champ had one of the most complete menus in the United States. Homer Rice bought the restaurant in 1947. In 1953, he changed the name to Rice's Dining Salon and installed a big sign with over 1,000 bulbs on it, making it visible for miles. He also owned a motel at the same location. (Curteich, 1948.)

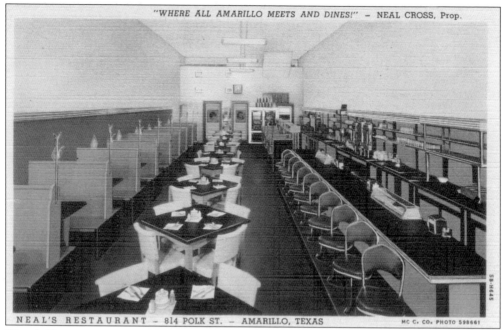

"WHERE ALL AMARILLO MEETS AND DINES!" – NEAL CROSS, Prop.

NEAL'S RESTAURANT – 814 POLK ST. – AMARILLO, TEXAS

NEAL'S RESTAURANT. Proprietor Neal Cross advertised his establishment at 814 Polk Street as "where all Amarillo meets and dines!" The card also reads, "Neal's Restaurant, across from the Paramount Theater, is the choice for fine food." (Curteich, 1945.)

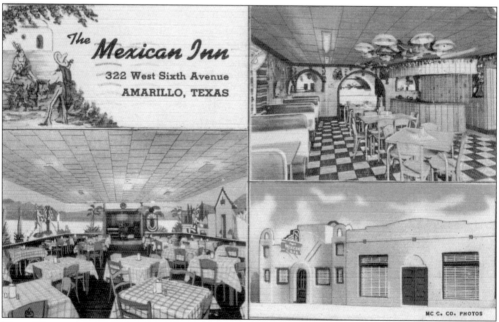

The **Mexican Inn**
322 West Sixth Avenue
AMARILLO, TEXAS

THE MEXICAN INN. Built in the mid-1940s, the colorful Mexican Inn at 322 West Sixth Avenue "offers both Mexican and American foods with music and dancing. Ralph Pelloe, Proprietor." In 1954, it was renamed to Lomax's Fine Foods. (Curteich, c. 1950.)

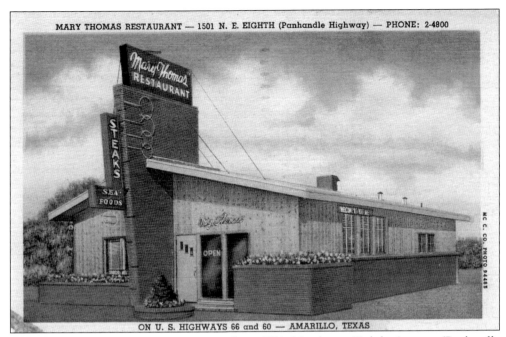

MARY THOMAS RESTAURANT — 1501 N. E. EIGHTH (Panhandle Highway) — PHONE: 2-4800

ON U. S. HIGHWAYS 66 and 60 — AMARILLO, TEXAS

MARY THOMAS RESTAURANT. Located at 1501 Northeast Eighth Avenue (Panhandle Highway) on U.S. Highways 66 and 60, Mary Thomas Restaurant was known for beefsteaks, Tennessee ham steaks, and seafood. The phone number was 2-4800. (Curteich, 1953.)

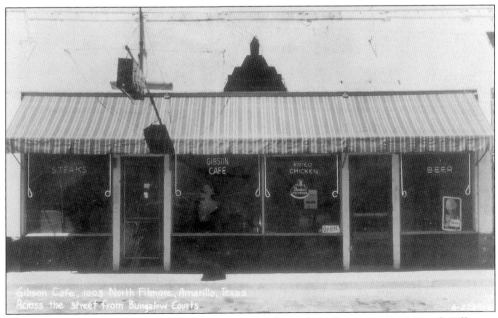

GIBSON CAFE. Located across the street from the Bungalow Courts at 1003 North Fillmore Street was the Gibson Cafe. It offered steaks, fried chicken, beer, and Borden's ice cream. The building featured in this *c.* 1940 real photo postcard has since been demolished.

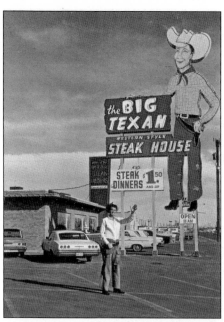

THE BIG TEXAN. This "Western-style steak house" was opened in 1962 by R. J. "Bob" Lee in the old Underwood Bar-B-Q building at 4515 Amarillo Boulevard East, on Route 66, the highway also known as "The Mother Road." The Big Texan was popular for the 72-ounce steak that was completely free as long as it was consumed in one hour. It touted "Texas Hospitality at its best. Texas' most unusual steak house—where you can select your own steaks, salad, potato, and homemade pastry. Watch your steak being charcoal broiled over an open flame." In the early 1970s, Lee moved the "Big Texan" sign to a new restaurant along East Interstate 40. (Baxter Lane Company, *c*. 1962.)

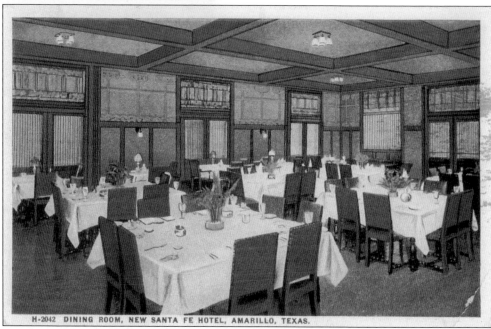

H-2042 DINING ROOM, NEW SANTA FE HOTEL, AMARILLO, TEXAS.

HARVEY HOUSE. The dining room of the new Santa Fe Hotel, located inside the Santa Fe Depot building, was one of the famous Harvey House restaurants that were located along the Santa Fe Trail. Harvey Houses started in Topeka, Kansas, and were the first chain restaurants. The women working there were known as Harvey Girls. The hotel closed in 1940, and the Santa Fe Depot building is now an auction house. The card reads, "Amarillo, Texas, is the county seat of Potter County and the metropolis of the famous Pan Handle country of Texas. The country surrounding is unsurpassed for beauty and fertility of soil. Amarillo is an important commercial and railway center and has a population between 12,000 and 15,000. Altitude 3,650 feet." (Fred Harvey, 1920.)

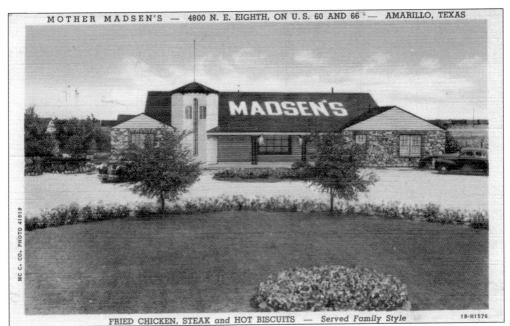

FRIED CHICKEN, STEAK and HOT BISCUITS — Served Family Style

MOTHER MADSEN'S. Located at 4800 Northeast Eighth Avenue on U.S. Highways 60 and 66, Mother Madsen's offered "fried chicken, steak and hot biscuits—served family style." Famed for 15 years for the best, genuine home cooking to be found on either U.S. Highways 60 or 66, it was also "recommended by Duncan Hines." (Curteich, 1941.)

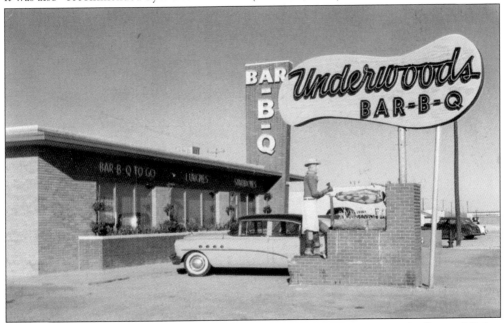

UNDERWOODS BAR-B-Q. Advertised as "by the pound to go. A cafeteria in the finest of dining rooms," the card also reads, "It is our experience and know-how that makes the difference." Built in 1956, Underwoods Bar-B-Q was originally located at 4513 Northeast Eighth Avenue on Route 66 before moving to 301 West Amarillo Boulevard around 1962. It closed for good in 1978. (Petley Studios, c. 1959.)

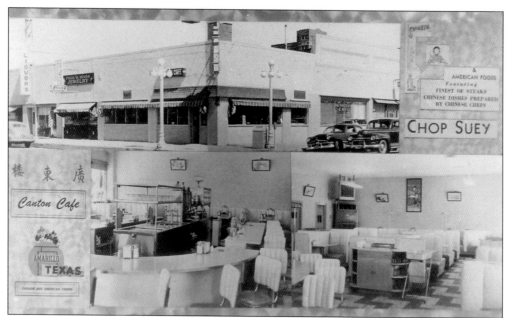

CANTON CAFE. This *c.* 1950 real photo postcard shows the café located on the corner of Fifth Avenue and Taylor Street. The Canton Cafe's "Chinese and American dishes" included the "finest of steaks, chop suey, and other Chinese dishes prepared by Chinese chefs." The restaurant stayed open until 2:00 a.m. every night. Next door was Fred W. Hinds Jewelry. The café was built in 1935, closed in 1968, and demolished shortly thereafter.

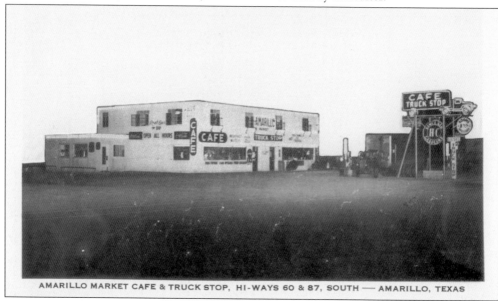

AMARILLO MARKET CAFE & TRUCK STOP, HI-WAYS 60 & 87, SOUTH — AMARILLO, TEXAS

AMARILLO MARKET CAFE AND TRUCK STOP. Located on U.S. Highways 60 and 87 South at 2700 Canyon Road, on route to beautiful Palo Duro Canyon, the Amarillo Market Cafe and Truck Stop offered Sinclair gasoline, 24-hour service, and copious parking. The café served fine steaks, seafood, and fried chicken as well as breakfast and waffles at all hours. Curb service was available in the summer. Mr. and Mrs. Boyd D. Cearly were the café owners. (Nationwide Specialty Company, *c.* 1955.)

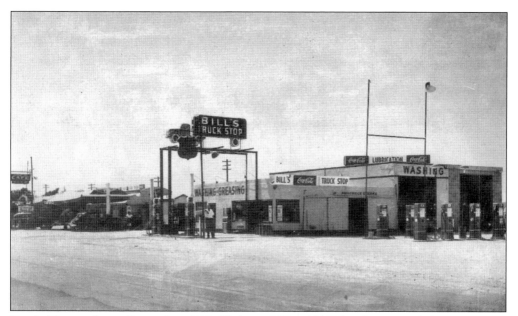

BILL'S TRUCK STOP. Located on U.S. Highway 287 at 4007 East Seventeenth Avenue in East Amarillo city limits was Bill's Truck Stop, visible in this *c.* 1950 card. The card reads, "There's never a time, day or night—seven days a week—when you can't get fast, satisfactory service on fuel, tires, and lubrication. Why not give us a try? This is a complete Truck Station." Phillips 66 Gasoline was available here.

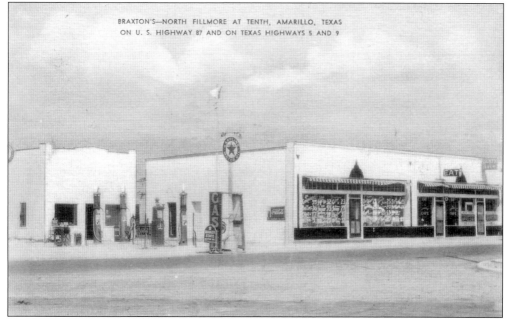

BRAXTON'S. Located at 1001 North Fillmore Street at Tenth Avenue on U.S. Highway 87 and Texas Highways 5 and 9, Braxton's sold Texaco gasoline, Texaco and Quaker State motor oils, and Blatz beer. Nancy's Café, Jacks Tavern, and a grocery store were also here. (McCormick Company, 1938.)

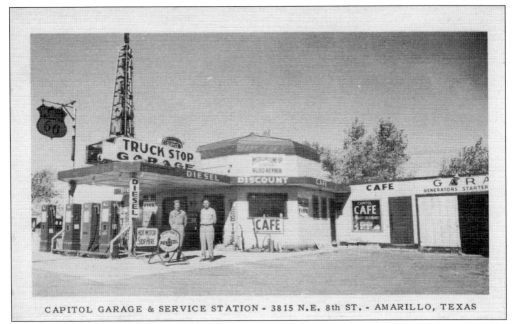

CAPITOL GARAGE & SERVICE STATION - 3815 N.E. 8th ST. - AMARILLO, TEXAS

CAPITOL GARAGE AND SERVICE STATION. Located at 3815 Northeast Eighth Street, the Capitol Garage and Service Station sold Phillips 66 gasoline and diesel fuel, kept Lee and Fisk tires in stock, and had a small eatery called the Capitol Cafe. There was an oil derrick sign on top of the building that rotated and had neon lights. This building was constructed in 1940, closed around 1964, and was torn down in 1980. (National Press, c. 1950.)

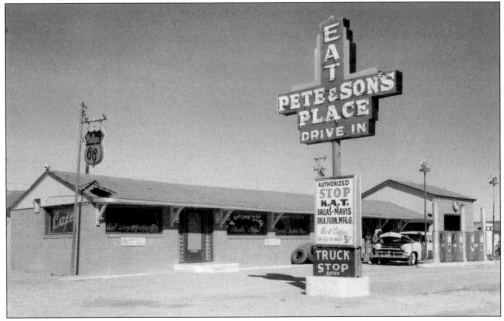

PETE AND SON'S PLACE DRIVE IN. Located at 5009 Northeast Eighth Avenue on U.S. Highways 66 and 60 East, Pete and Son's Place advertised, "Baked ham and steaks our specialty." It also sold hot dogs, hamburgers, steaks, and chops. The Phillips 66 drive-in and truck stop served "the best coffee on this highway—5 cents." (McCormick Company, c. 1950.)

Seven

HOSPITALS
AND SCHOOLS

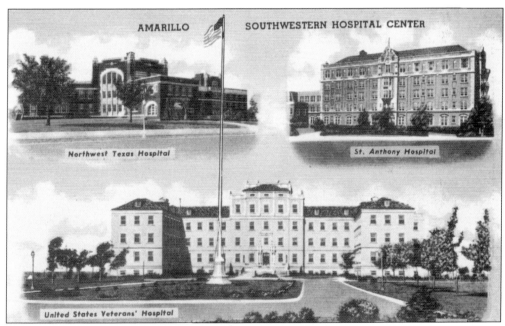

AMARILLO SOUTHWESTERN HOSPITAL CENTER. This multi-view postcard shows the three hospitals of Amarillo, Texas: Northwest Texas Hospital, St. Anthony Hospital, and U.S. Veterans Hospital. The back of the card reads, "Wholesale, transportation, petroleum, natural gas, helium, hospital, and Federal hub of a fast growing region larger than Pennsylvania area. Capacity of the three hospitals pictured 410 beds." (West Texas News Agency, *c.* 1940)

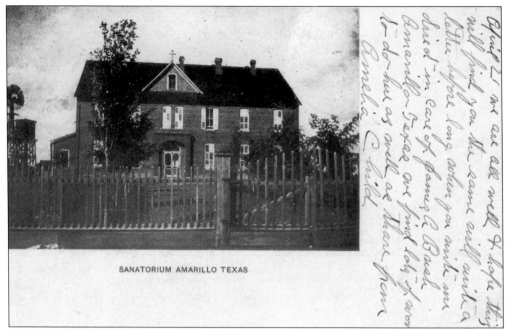

SANATORIUM AMARILLO TEXAS

SANATORIUM. The original sanatorium was located at Seventh Avenue and North Polk Street and was built in 1901. At the time, there were no gas heating, electricity, running water, or sewage drainage disposal system. A windmill provided fresh water. (Schwarz and Company, 1907.)

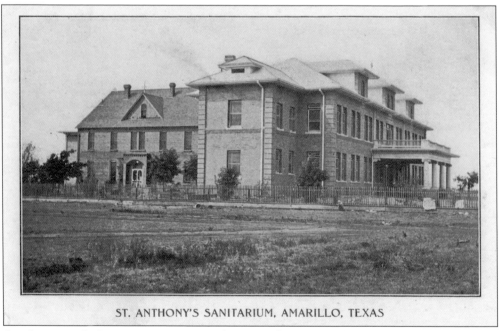

ST. ANTHONY'S SANITARIUM, AMARILLO, TEXAS

ST. ANTHONY'S SANITARIUM. In 1909, the original sanitarium building was joined by a new three-story addition. On the left is the original two-story building, and on the right is the addition. This expansion provided 30 new beds. (L. H. V. Reynolds and Company, c. 1910.)

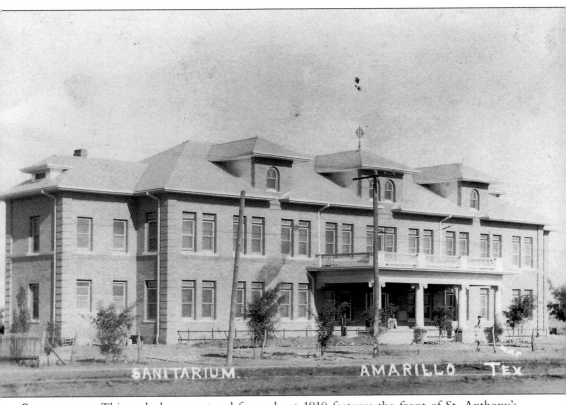

Sanitarium. This real photo postcard from about 1910 features the front of St. Anthony's Sanitarium hospital.

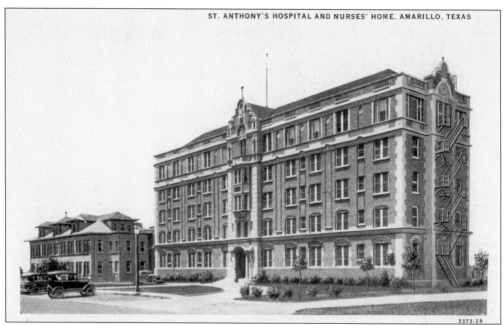

ST. ANTHONY'S HOSPITAL AND NURSES' HOME. As Amarillo grew, the city needed a larger hospital. The building on the right is the five-story, 100-bed hospital that was constructed in 1928. The old three-story hospital, on the left, was turned into a nurses' home. (McBride News Agency, *c.* 1930.)

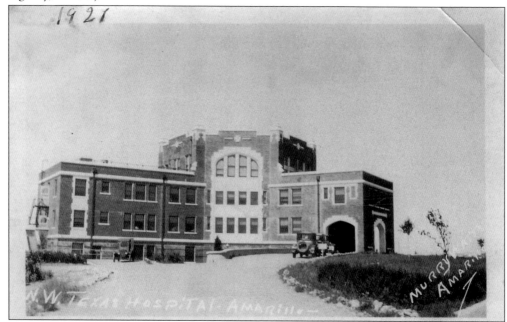

NORTH WEST TEXAS HOSPITAL. This real photo postcard shows North West Texas Hospital, Amarillo's first public hospital. Built in 1924, it was located in the 2300 block between Sixth and Seventh Avenues. A private room was $6 per night, and a double room was $4 per night. In 1982, it moved to a new location. It is now known as Northwest Texas Healthcare System. (Murry Watts, *c.* 1925.)

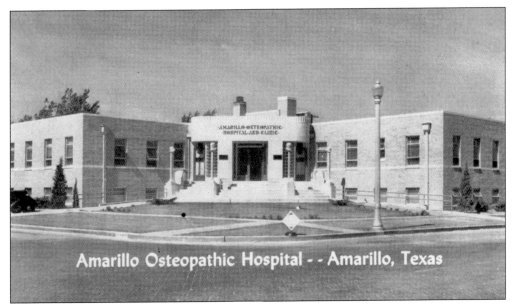

Amarillo Osteopathic Hospital - - Amarillo, Texas

AMARILLO OSTEOPATHIC HOSPITAL AND CLINIC. Visible in this *c.* 1945 card is the hospital that was once located on the southwest corner of 801 West Tenth Avenue and Jefferson Street. This was originally known as Amarillo General Hospital. The building is still there today, but the hospital is no longer located there.

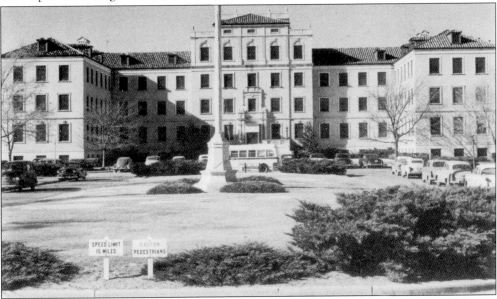

U.S. VETERANS HOSPITAL. The hospital in this *c.* 1955 card was built in 1940 by the Works Progress Administration (WPA) on 360 acres of farm and ranch land. A few years later, most of the land was returned to the General Services Administration, which kept only 43 acres. Cattle were raised and gardens were maintained to feed the veterans. In 2004, the name was officially changed to Thomas E. Creek (a Medal of Honor recipient) Department of Veterans Affairs Medical Center. The buildings are of early Spanish architecture with the first ones being listed on the National Register of Historic Places. The hospital has undergone several remodels and additions and is still open today.

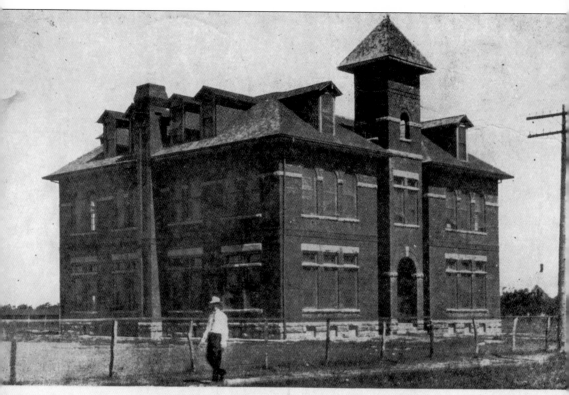

Polk Street, Amarillo, Tex.

POLK STREET SCHOOL. This 1909 card depicts the structure known as "The Red Brick" school, located between Twelfth and Thirteenth Avenues on Polk Street—an area considered to be out in the country at the time. Sheds were provided for the students coming in from the ranches to shelter their horses and donkeys. School started here in October 1900, but the third floor remained unfinished until December of that year. Around 1903, the school became so overcrowded that plans were made for a new schoolhouse on Johnson Street. This building was torn down in 1921, so a new high school building could be constructed.

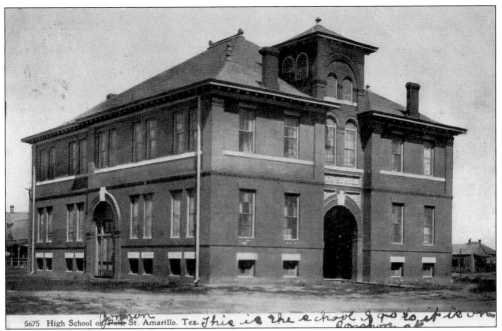

5675 High School on Polk St. Amarillo. Tex. *This is the school I go to it is one*

HIGH SCHOOL ON POLK STREET. As indicated by someone, the school was actually located on Johnson Street and not Polk Street. Built in 1905, it was known as the Johnson Street School and was located between Fifth and Sixth Avenues. In 1911, it moved to a new building on Twelfth Avenue and Polk Street. On the front of the building, above the doors, are the words "High School." (Adolph Selig Publishing Company, 1908.)

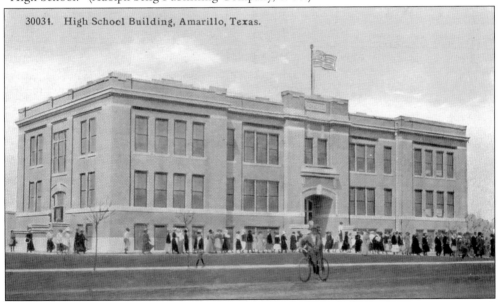

30031. High School Building, Amarillo, Texas.

HIGH SCHOOL BUILDING. Pictured in 1912, this tan school building was located at Fourteenth Avenue and Polk Street, just south of "The Red Brick" schoolhouse. It was built in 1911. While occupying this building in 1913, the school started its first football team. It remained the high school until 1922. This building was demolished in the 1960s to make room for a gymnasium.

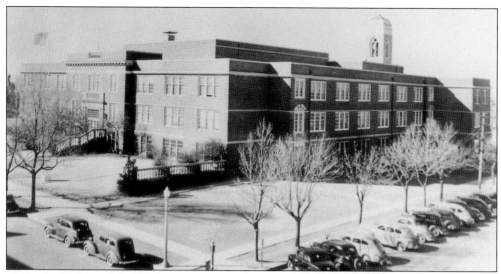

AMARILLO HIGH SCHOOL. This high school was built in 1922 at Twelfth Avenue and Polk Street. Across the street from the school, the Double Dip Drive-In opened in 1930. It was a popular spot for the high school students for lunches and get-togethers. The Double Dip served hamburgers, ice cream, soft drinks, and other lunchtime favorites. This was the only high school in town until 1956 when Palo Duro High School was built. In 1970, there was a fire that destroyed the building. In the top right-hand corner one can see the bell tower of the First Baptist Church at Twelfth Avenue and Tyler Street. This is a *c.* 1940 real photo postcard.

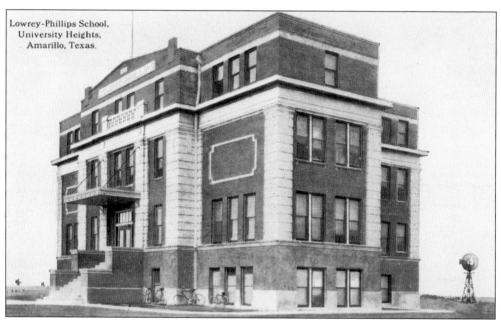

LOWREY-PHILLIPS SCHOOL. The Lowrey-Phillips School was in University Heights a few blocks north of present-day Amarillo Boulevard. This was a three-story brick building that came to be in 1914. The private school provided education for elementary through junior college students. The original school was opened in 1910 by Dr. B. G. Lowrey and F. F. Phillips. The school closed in 1917. (The Nickel Store, *c.* 1912.)

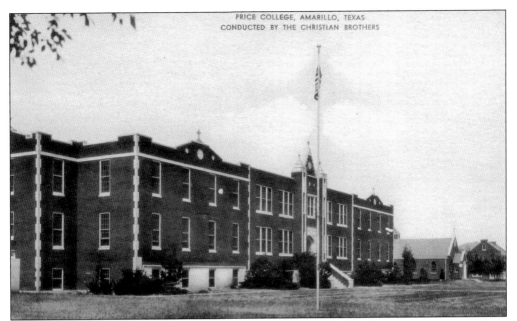

PRICE MEMORIAL COLLEGE. Conducted by the Christian Brothers, this Catholic boys school was originally named St. George's College. Located at 1800 North Spring Street, it was built in 1928. In 1929, it became Price College and began to allow girls to be enrolled. It is still open today and is now known as Alamo Catholic High School. (McCormick Company, *c.* 1940.)

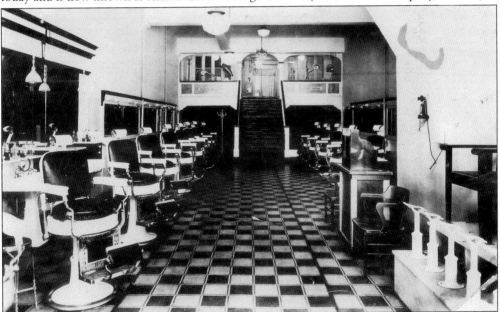

DENDY'S SYSTEM OF COLLEGES. Dendy Union Barber College, operated by "J. M. Dendy, Proprietor" at 316 Polk Street, was "equipped with the most modern equipment. This is one of the most attractive and sanitary colleges in the southwest," according to the card. In this image, above the barber chairs on each side of the stairs, signs read "Dendy's" (left) and "Beauty Parlor" (right). On the back, the card also states, "Beauty school in connection, Marinello System." (Grocan Photo System Inc., *c.* 1940.)

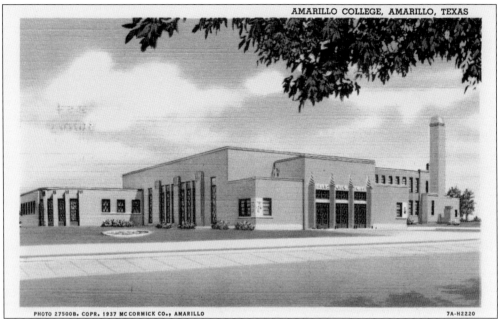

PHOTO 27500B. COPR. 1937 MCCORMICK CO., AMARILLO 7A-H2220

AMARILLO COLLEGE. Originally started in the municipal auditorium on Lincoln Street, Amarillo College later was located at Twenty-fourth Avenue and Washington Street. In its new home, this fully accredited, municipal, coeducational junior college, specializing in preprofessional courses, has one of the finest and most modern school plants in the Southwest. It was built in 1930. It is still in operation today. (Curteich, 1937.)

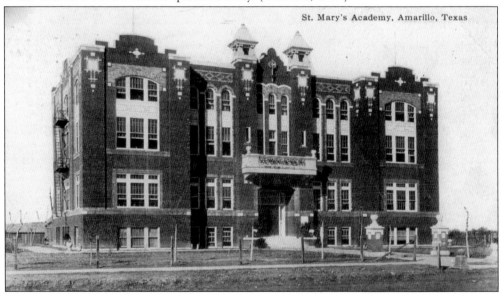

St. Mary's Academy, Amarillo, Texas

ST. MARY'S ACADEMY. Pictured in 1917, this building at 1200 Washington Street was founded in 1913 as St. Mary's Academy and is still open today as St. Mary's School. The school was founded in Clarendon in 1899 by the Sisters of the Incarnate Word and was moved to Amarillo. Originally a school for girls, it became a preschool and elementary school for both boys and girls in the 1920s. This was the city's first Catholic school and was the only one in the Texas Panhandle for many years.

Eight

FIRE STATIONS, COURT HOUSES, AND POST OFFICES

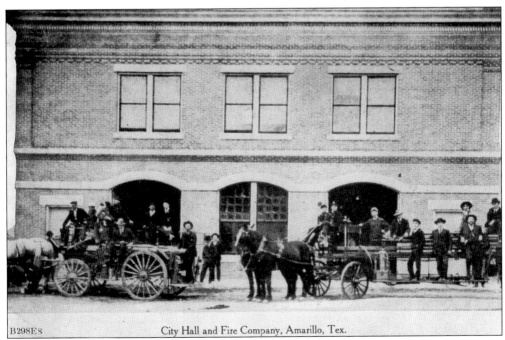

CITY HALL AND FIRE COMPANY. Pictured in 1908, this structure was located in the 100 block of West Fourth Avenue. The fire department was built in 1907. There were two wagons—one a pump wagon and the other a hose wagon—and the horses were used to pull the fire equipment wagons. The complex also housed the public library and city hall.

City Hall and Fire Station,
 Amarillo, Texas.

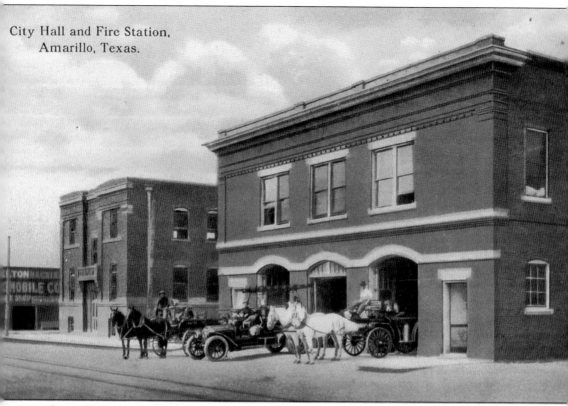

CITY HALL AND FIRE STATION. By 1912, the fire department (right) had acquired an automobile, which was probably reserved for the fire chief. Notice how the car is driven on the right-hand side and not the left. (The Nickel Store, 1912.)

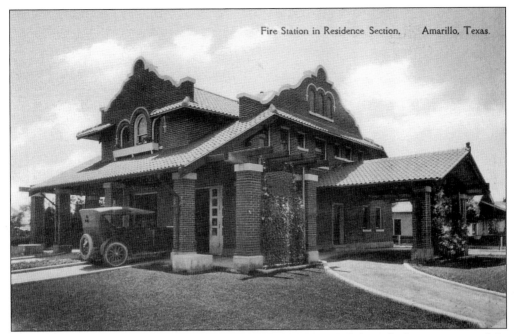

FIRE STATION IN THE RESIDENCE SECTION. The city decided that it had grown so much in the south part of town that it needed a second fire station, so this fire station was built, the city's second, at 1601 South Harrison in 1914. This building was demolished, and a new fire station was constructed on this site in 1959. (The Albertype Company, *c.* 1915.)

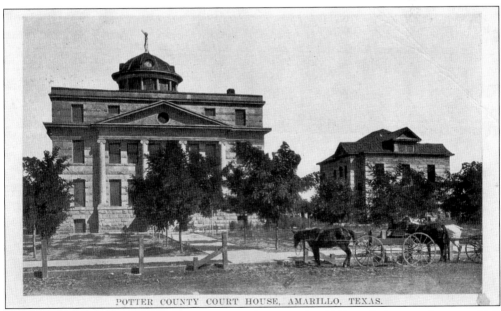

POTTER COUNTY COURT HOUSE, AMARILLO, TEXAS.

POTTER COUNTY COURTHOUSE AND JAIL. Shown in this 1910 card, the courthouse and jail building was located at 501 South Taylor Street and constructed in 1906. There was a statue of Lady Liberty mounted on top of the dome holding the scales of justice. The two-story building on the right was the jail. It was demolished in 1930, and the new courthouse was built on this site.

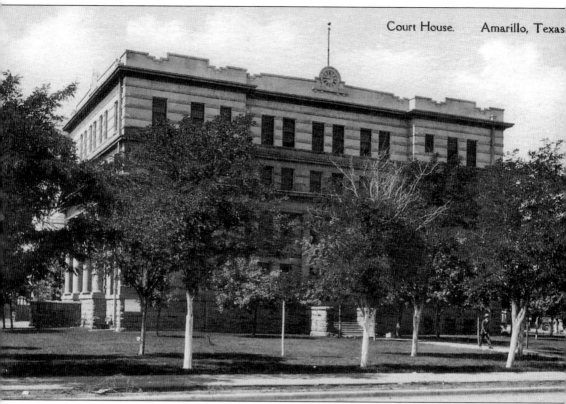

Court House. Amarillo, Texas

POTTER COUNTY COURTHOUSE. A few years after the original courthouse was built, the dome was removed and another floor was added. The structure was demolished in 1930 to make way for a new courthouse on this site. (The Albertype Company, *c.* 1920.)

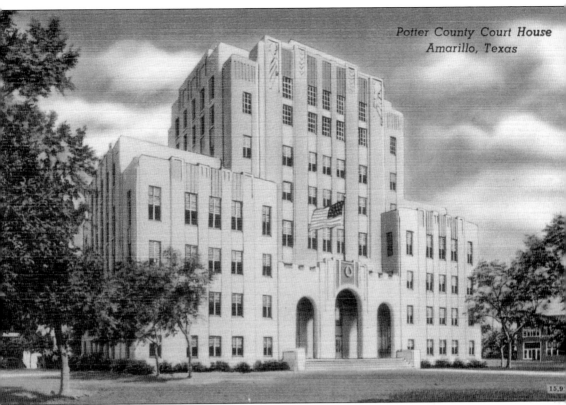

Potter County Court House
Amarillo, Texas

NEW POTTER COUNTY COURTHOUSE. This courthouse was constructed in 1932 at 501 Taylor Street. In 1986, a new courthouse was built across the street. This building is still in use today. (West Texas News Agency, *c.* 1935.)

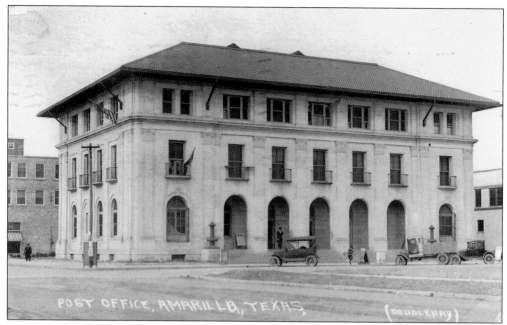

POST OFFICE. Amarillo's post office moved locations several times before this facility was constructed in 1914 as Amarillo's first post office building. Located at 620 Taylor Street, this was the post office until 1939 and is known today as the Coble Building. (Doubleday, 1921.)

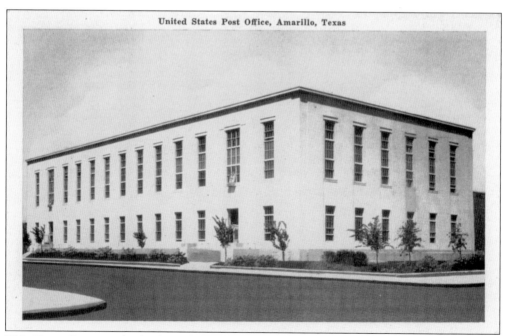

U.S. POST OFFICE. This building at 207 Fifth Avenue was constructed in 1939 and used as the post office until 1977. Located on the site of the old Elmhirst Hotel, it still stands today and is now the Federal Building. (Graycraft Card Company, *c.* 1950.)

Nine

RAILROADS

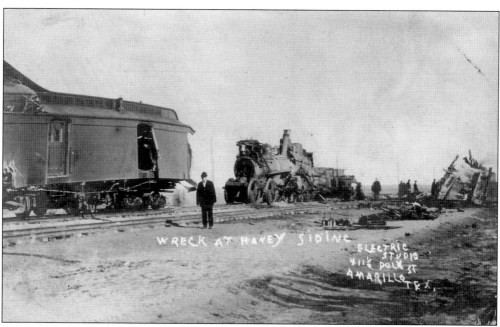

WRECK AT HANEY SIDING. On December 6, 1908, an eastbound Santa Fe railroad passenger train and westbound Santa Fe railroad passenger train collided head-on at Haney Siding, which is south of Amarillo going toward Canyon. Three people died in the collision. This real photo postcard of the wreck was taken by the Electric Studio that was located at 411½ Polk Street. (Electric Studio, 1908.)

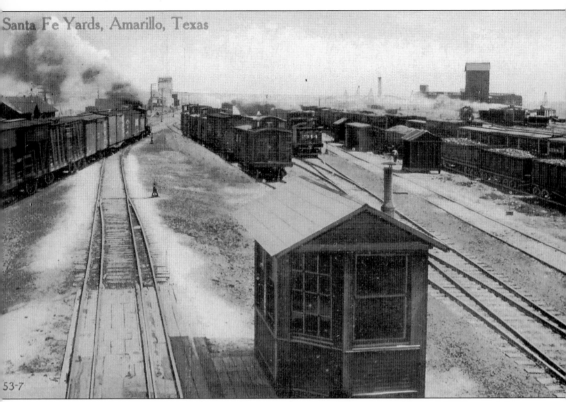

53-7

SANTA FE YARDS. These yards were very busy, as this was a main line for the Santa Fe Railroad. There were trains coming in and out of the yards at all hours of the day and night. All of the locomotive engines in this scene are steam engines. On the left side of the card is the Yard Masters Office, which is no longer there and has been replaced by a tower. Just below the tall building on the right is the Round House, which is no longer there either, though the platter survives. In the background are two grain elevators and several windmills. This view is looking north from about where Interstate 40 is located today. The yards are still in use today. (Fred Harvey, *c.* 1920.)

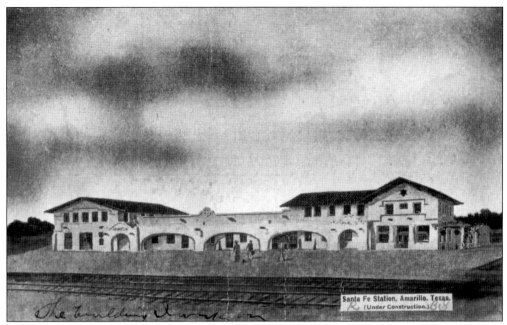

SANTA FE STATION. The station is under construction in this 1910 image, and it looks like this is before a second floor and hotel were added. The depot fronted Fourth Avenue off of Grant Street. (Joiner Printing Company, 1910.)

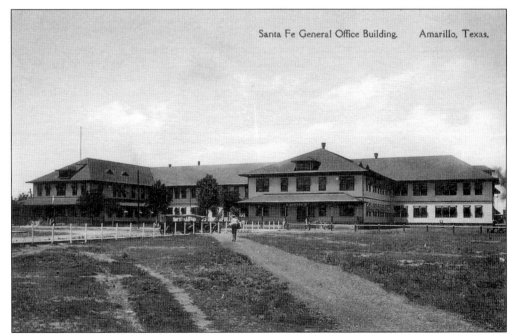

SANTA FE GENERAL OFFICE BUILDING. This building housed the offices, depot, and the hotel. A second story with a hotel was added two years later. It also housed a Fred Harvey restaurant, the Harvey House. (The Albertype Company, *c.* 1920.)

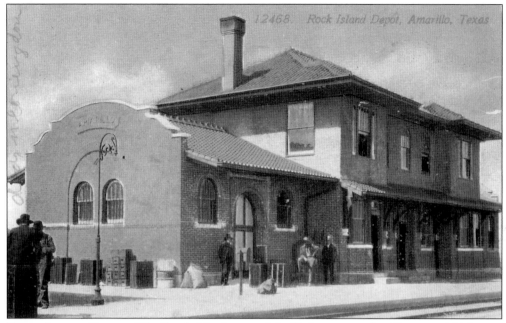

ROCK ISLAND DEPOT. The Rock Island was originally known as the Choctaw, Oklahoma, and Texas Railway. It was also known as the Chicago, Rock Island, and Pacific Railroad. The depot was located at 100 North Polk Street. It was built in 1910 and torn down in 1986. (The Acmegraph Company, 1915.)

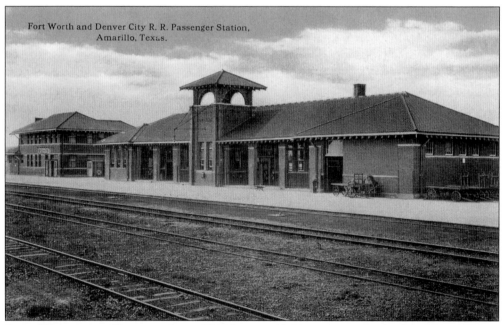

FORT WORTH AND DENVER CITY. This depot at 83 Pierce Street was built in 1910. In 1951, the name was changed to Fort Worth and Denver Railway Company, and in 1982 it merged with the Burlington Northern Railway. (The Nickel Store, *c.* 1915.)

Ten

HAPPENINGS IN
AND AROUND AMARILLO

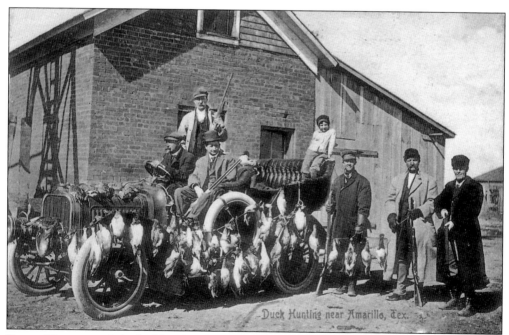

DUCK HUNTING. It looks like this duck-hunting trip was very successful, as there must be around 50 ducks hanging from the car. Notice how the car is driven from the right side and not the left. (L. O. Thompson and Company, 1910.)

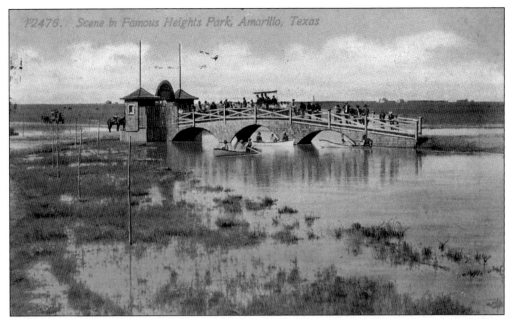

SCENE IN FAMOUS HEIGHTS PARK. Famous Heights Park was located on the east side of the city by the Tee Anchor Lake, north of present-day Interstate 40, and east of Ross Street. The lake inside the park featured a horse-race track going around its perimeter. Once inside the gate area, one could rent boats to ride around the lake in. Houses are visible in the background. (The Acmegraph Company, 1914.)

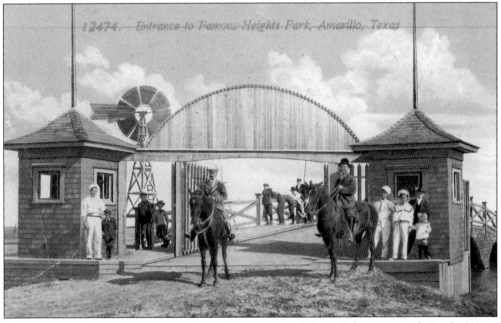

ENTRANCE TO FAMOUS HEIGHTS PARK. Guests entered the park here to pay their admission. (The Acmegraph Company, 1917.)

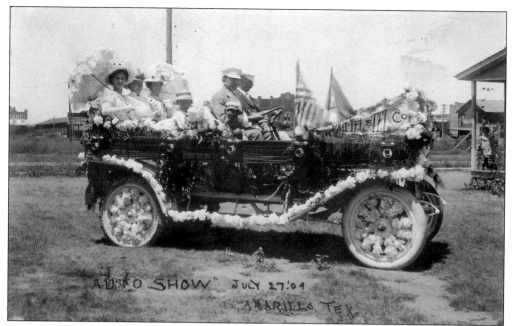

AUTO SHOW, JULY 27, 1909. Decorated with flowers and telephones, this car was sponsored by Pan Tel and Telephone Company, as visible from the banner on the hood of the car. In the background, behind the automobile, one can see the H. A. Campbell Plumbing building on Polk Street. The driver has his dog in his lap, and the dog has a hat on that states, "PT&T Co." This is a 1909 real photo postcard. The car is right-hand drive.

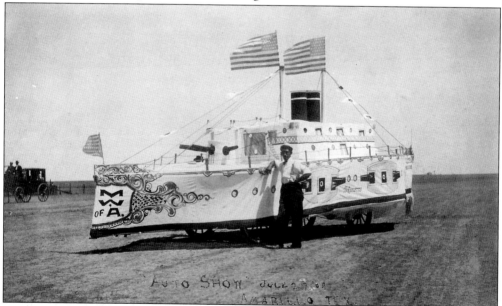

BATTLESHIP AT AUTO SHOW, JULY 27, 1909. This battleship float has the letters "M W of A" on the bow of the ship. The author believes this stands for "Modern Woodmen of America." "The Ricketts" is printed on the side of the float. To the left of the float is an old wagon. On the right, behind the ship, is a house and windmill in the far distance. The auto show started out as a parade on Polk Street and became an annual event. This is a 1909 real photo postcard.

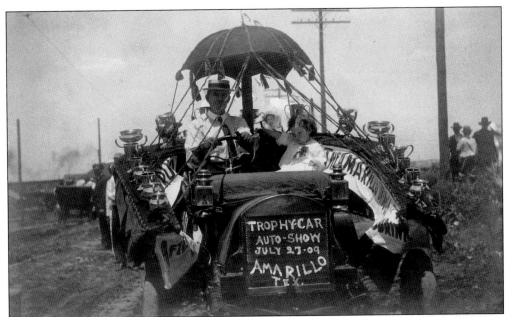

TROPHY CAR AT AUTO SHOW, JULY 27, 1909. It is unclear whether the trophies were just decorations for the car or if they were to be given away. At any rate, there were lots of trophies mounted on both sides of the car. The platform on which the trophies were mounted was shaped like a horseshoe around the car. The little girl sitting beside the driver does not look very happy in this 1909 real photo postcard. The car is right-hand drive.

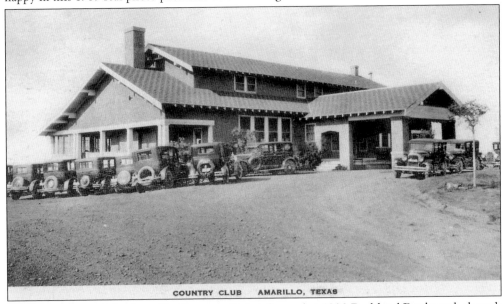

COUNTRY CLUB AMARILLO, TEXAS

COUNTRY CLUB. The Amarillo Country Club is located at 4800 Bushland Boulevard, though the official address of the golf course is 4900 West Ninth Avenue. Built in 1919, this was and still is a very popular private country club, featuring an 18-hole golf course, a dining room, a card room, tennis courts, and a swimming pool. The club held dances and offered dance lessons. Amarillo Country Club was recognized as having "one of the finest golf courses west of Fort Worth." (The Albertype Company, *c.* 1930.)

120

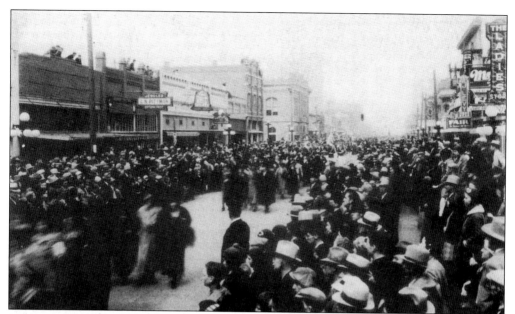

MOTHER-IN-LAW DAY PARADE. The Mother-in-Law Day Parade was held by Gene Howe on March 9, 1938, and took place on Polk Street. A record crowd viewed the parade. This view shows Sixth Avenue and Polk Street looking north.

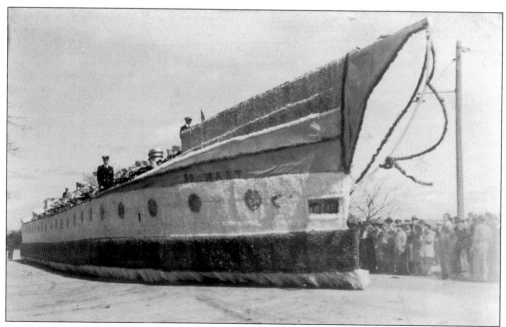

SS *MARY*. The *Mary* was the "world's longest float" at 165 feet, and it carried 500 mothers-in-law for the fifth-annual Mother-in-Law Day Parade on March 9, 1938.

ELEANOR ROOSEVELT AND DAUGHTER ETHEL. Mrs. Franklin D. Roosevelt was in town because she was invited to be the guest of honor at the fifth-annual Mother-In-Law Day Parade in March 1938. Roosevelt rode at the head of the parade in an "Eleanor blue" Buick that was especially designed for the first lady. Upon completing the route, she watched the rest of the parade from a reviewing stand and was presented with a bouquet of 5,000 fresh roses.

MRS. ROOSEVELT AND DAUGHTER ETHEL.

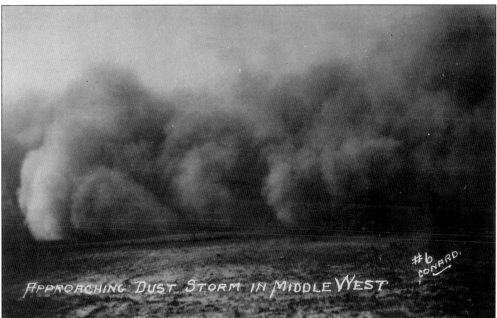

ROLLING DUST CLOUDS. "Approaching Dust Storm in Middle West," states this real photo postcard. The image shows the dark clouds rolling in on what was called Black Sunday. Droughts and winds were the main causes of these dust storms during the Depression. This particular storm destroyed property and killed many people. A significant number of people moved away after a series of dust storms plagued the area. (Conard, 1935.)

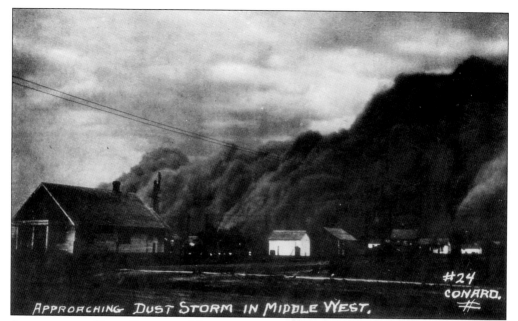

APPROACHING DUST STORM IN MIDDLE WEST. In this 1935 card, an ominous cloud of dust rolls in and extinguishes the light of day. (Conard, 1935.)

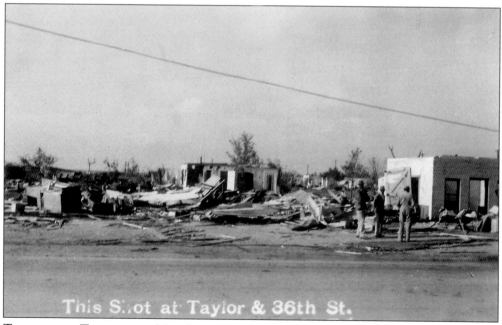

TORNADO AT TAYLOR AND 36TH STREETS. This 1949 real photo postcard shows the aftermath of a tornado that destroyed several houses and damaged many more on May 15, 1949. The tornado hit in the southeast part of town and destroyed 15 blocks. This was the worst weather disaster Amarillo had seen.

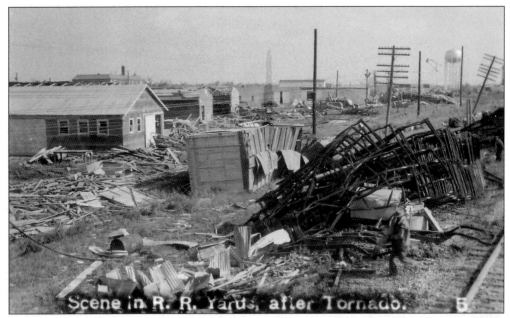

SCENE IN THE RAILROAD YARDS AFTER TORNADO. These are the yards around the Forty-fifth Avenue and Washington Street area. This card shows the aftermath of the tornado that twisted and mangled all of the steel railcars on May 15, 1949.

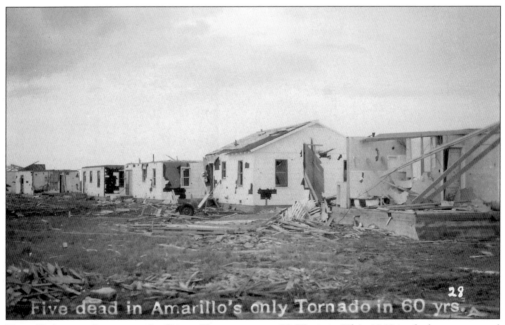

FIVE DEAD IN AMARILLO'S ONLY TORNADO IN 60 YEARS. This 1949 real photo postcard shows the residential damage done by the deadly tornado.

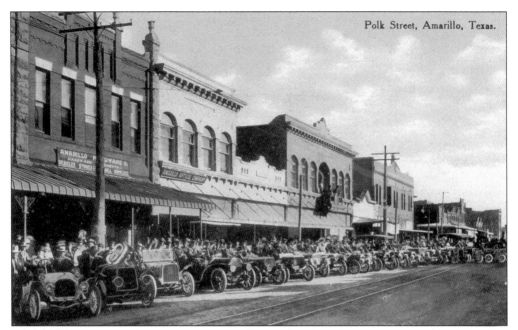

POLK STREET AUTO DAY. A whole host of people on Polk Street are pictured climbing into their cars on Auto Day. Perhaps the horn was broken on the second car from the left. How else to explain the tuba? The building on the left is Amarillo Hardware. (The Nickel Store, 1910.)

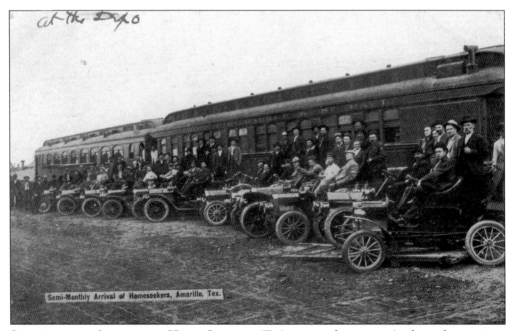

SEMIMONTHLY ARRIVAL OF HOME SEEKERS. Twice a month, prospective home buyers were brought to Amarillo via railroad. Cars provided by eager land developers waited for the buyers. (Joiner Printing Company, *c.* 1910.)

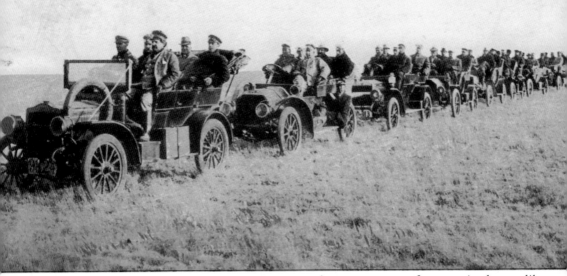

A BUNCH OF HOME SEEKERS. It was not unusual to see a group of prospective buyers like this one trekking out across the prairie, led by land developers selling in Amarillo's outlying regions. (H. G. Zimmerman and Company, 1912.)

BIBLIOGRAPHY

Amarillo Globe News. Various issues.

Barnett, Lana Payne. *Presenting the Texas Panhandle.* Canyon, TX: Lan-Bea Publications, 1979.

Boggs, Johnny D. *That Terrible Texas Weather.* Plano, TX: Republic of Texas Press, 2000.

Carson, Paul Howard. *Amarillo: The Story of a Western Town.* Lubbock, TX: Texas Tech University Press, 2006.

City Directories, Amarillo: 1914–1956. Amarillo, TX: Amarillo Public Library.

Franks, Ray, and Jay Ketelle. *Amarillo, Texas: The First Hundred Years: 1887–1987.* Vol. I and II. Amarillo, TX: Ray Franks Publishing Ranch, 1986.

Hammond, Clara T. *Amarillo.* Austin, TX: Best Printing Company, Inc., 1974.

Key, Della Tyler. *In the Cattle Country: History of Potter County.* Wichita Falls, TX: Nortex Offset Publications, Inc., 1972.

Lynch, Etta. *The Tactless Texan.* Canyon, TX: Staked Plains Press, 1979.

Nail, David L. *Amarillo Montage.* Canyon, TX: Staked Plains Press, 1979.

———. *One Short Sleep Past.* Canyon, TX: Staked Plains Press, 1973.

Price, B. Byron. *The Golden Spread: An Illustrated History of the Texas Panhandle.* Northridge, CA: Windsor Publications, Inc., 1986.

Stanley, F. *The Texas Panhandle.* Borger, TX: Jim Hess Printers, 1971.

The Handbook of Texas Online. Texas State Historical Association.

www.arcadiapublishing.com

Discover books about the town where you grew up, the cities where your friends and families live, the town where your parents met, or even that retirement spot you've been dreaming about. Our Web site provides history lovers with exclusive deals, advanced notification about new titles, e-mail alerts of author events, and much more.

MADE IN THE USA

Arcadia Publishing, the leading local history publisher in the United States, is committed to making history accessible and meaningful through publishing books that celebrate and preserve the heritage of America's people and places. Consistent with our mission to preserve history on a local level, this book was printed in South Carolina on American-made paper and manufactured entirely in the United States.

This book carries the accredited Forest Stewardship Council (FSC) label and is printed on 100 percent FSC-certified paper. Products carrying the FSC label are independently certified to assure consumers that they come from forests that are managed to meet the social, economic, and ecological needs of present and future generations.

FSC
Mixed Sources
Product group from well-managed forests and other controlled sources

Cert no. SW-COC-001530
www.fsc.org
© 1996 Forest Stewardship Council

Find *Your* Place in History.